THE
GRAND VALLEY

Three Paintings Trilogy: Volume 3

THE
GRAND VALLEY

On Going to Hell, to France, and Back to Childhood

MORGAN MEIS

SL /. NT
B O O K S

THE GRAND VALLEY
On Going to Hell, to France, and Back to Childhood

Three Paintings Trilogy: Volume 3

Copyright © 2025 Morgan Meis. All rights reserved. Except for brief quotations in critical publications or reviews, no part of this book may be reproduced in any manner without prior written permission from the publisher. Write: Permissions, Slant Books, P.O. Box 60295, Seattle, WA 98160.

Slant Books
P.O. Box 60295
Seattle, WA 98160

www.slantbooks.com

Cataloguing-in-Publication data:

Names: Meis, Morgan.

Title: The grand valley: on going to hell, to france, and back to childhood / Morgan Meis.

Description: Seattle, WA: Slant Books, 2025

Identifiers: ISBN 978-1-63982-200-3 (hardcover) | ISBN 978-1-63982-199-0 (paperback) | ISBN 978-1-63982-201-0 (ebook)

Subjects: LCSH: Mitchell, Joan, 1925-1992 | Painting, American 20th century | Abstract expressionism | Monet, Claude, 1840-1926

Contents

Preface • xi

1. One day in 1983 Joan Mitchell started painting a bunch of paintings. You could call them landscapes. Or are they something else? She painted, finally, twenty-one versions of this place that wasn't quite a place. These great paintings are hard to understand. • 1

2. We are introduced further to Joan Mitchell and to the puzzles and mysteries of Joan Mitchell and that leads to a more general discussion of difficult people and what makes them also wonderful. • 7

3. The pain and difficulty of Joan Mitchell's paintings, which can be very difficult and painful indeed. The difficulty of people who show things by hiding and vice versa, people like, for instance, Gertrude Stein and Alice B. Toklas. • 14

4. Joan Mitchell was an abstract painter, more or less. But what is that, really? What were mid-twentieth century abstract painters trying to do? What was Joan Mitchell, specifically, trying to do with

abstraction and, also, isn't it interesting to talk about Clyfford Still sometimes? • 25

5. What is a landscape? What is a crucifixion scene? And why did John Ashbery know so much about what Joan Mitchell was doing and why she went to France? • 38

6. A return to Gertrude Stein and Alice B. Toklas and some reflections on *The Making of Americans*, Gertrude Stein's most brilliant and unaccountable work. And are there two Gertrude Steins? • 48

7. The critic and personality Dave Hickey enters the picture. He brings with him the idea, which he repudiates, of there being two Joan Mitchells, Big Joan and Little Joan. The existence and the nonexistence of Big Joan and Little Joan. • 56

8. Talking about Dave Hickey forces us to talk about Carl Gustav Jung, the Swiss academic and also, it turns out, strange mystic or prophet or something. This Swiss person took a train ride to hell and came back with some interesting news. • 62

9. More is learned about the travels of Carl Gustav Jung into hell. Hell is a place that must be encountered. Down there in hell, you learn to be the person you had always been in the first place. It's a paradox. But a nice one. • 66

10. Back to Joan Mitchell and the intractable France problem. And not just France, but a little town in France in particular. You can't confront Joan Mitchell without also confronting Vétheuil, which also means confronting Monet, which also means confronting sunflowers, which also means confronting death. • 71

11. A few more brief thoughts on loss and death. • 84

12. Going to hell. Lots of people have done it. Odysseus did it. He did it because of Circe. And what does any of this have to do with Poseidon? What do the depths conceal? • 86

13. Some further thoughts about Jean-Paul Riopelle. The beast plays his role and runs off with the dog walker, as was also necessary. • 92

14. The wrongness of Dave Hickey even though he was also a little bit right. Also, the letter "S" is red. And the importance of paintbrushes, lots of them. The way that Joan Mitchell went within herself and then beyond herself when she was alone with her brushes. • 97

15. On the nature of the self, which has no nature. On the paradox of the self, which isn't even a paradox, because it is nothing. The something of a nothing. The importance of music. The importance of the sound of certain human voices. The infinity of certain experiences. • 106

16. Joan Mitchell sees the direction in which art history is going and runs in the opposite way. Joan Mitchell feels sorry for herself after Jean-Paul Riopelle runs off with the dog walker. Joan listens to opera. Opera leads to considerations of some of the great fuckfests of history. • 115

17. Another glimpse into history as a test. Another glimpse into the denials of the great losers. The way rarely taken: Dido, Carthage, the Suffering Servant. • 129

18. We get a little abstract and we make up a bunch of words and phrases in order to describe what Joan Mitchell was doing on the canvases she painted in 1964, a kind of *annus mirabilis* for Joan Mitchell in which she obliterated herself and therefore also became most herself. • 133

19. The ongoing painterly descent of Joan Mitchell and then the unexpected appearance of Hugo von Hofmannsthal, Francis Bacon, and *The Lord Chandos Letter*. The secret that is held within the terrible dying of the rats. • 141

20. From the terrors of *The Lord Chandos Letter* to the obsessions of Monet and the repetitive nature of Impressionism at its essence. The fear and desire that drives Monet forward. • 148

21. Where we explore the fact that Joan Mitchell, who not only went to live more or less in Monet's old

house, also took on large painting projects that are not unlike what Monet took on in his serial paintings. • 155

22. A little dive into the lives of children and how they experience special places and then how that experience might be transferred into a specific style of painting, a specific style of painting that was of specific interest to Joan Mitchell. • 159

23. Why was Monet so obsessed with water lilies? Why did he paint the same subject matter over and over? What happened in those final paintings where the water lilies seem to become unmoored from any anchor in visual reality? • 164

24. The unique way that space and distance operates in the special places where children go. The big valley is a place you can't go to. You are either in it or you aren't. There's a way to paint that, it turns out. • 173

25. Joan Mitchell had a relationship with previous painters and she acknowledges this. But she was never happy being compared to Monet. And she was never happy with what anyone said about her paintings. She was not happy with theories about art. She was not happy. She preferred to say no. • 176

26. Joan Mitchell and the serpent. • 182

27. Carl Jung and the serpent. • 186

28. Lord Chandos and the serpent. • 190

29. Paintings and words. • 193

30. The final whirlpool into which Monet descended in his final paintings of the water lilies. • 195

31. The final whirlpool of language that eats itself in the ouroboros of Gertrude Stein's *The Making of Americans*. • 198

Further Reading • 202

Preface

I DON'T REMEMBER when or where I saw my first Joan Mitchell painting. I have a vague sense of having seen one of the tree paintings many decades ago. Joan Mitchell painted a lot of paintings that have trees in them. The color blue often predominates in these paintings. None of the trees are very well articulated as trees, at least if you're looking for some image you could immediately identify as a tree. Much of the time, Joan Mitchell painted trees as just a few scribbly lines of paint up and down on the canvas. As I remember it, the trees or the landscape or whatever it was bothered me. The painting seemed so messy. At least, that's how I remember it now, though I don't remember when or where that was. I don't remember. I just have a feeling, a feeling of my own discontent and even disappointment.

But the painting stayed with me, I guess. I have little notes in files that can be found in forgotten places, forgotten to me at least, hidden-away spots that go back into the depths of my Google drive. The kinds of files that you only find when you open up an old folder and that folder has other even older files inside and you keep going back into the murky places, into the corners

Preface

of your Google drive where you are, inevitably, a little scared to go. Because what's in there? Who was I then? How much of myself have I forgotten, even from just a few years ago?

Anyway there are files. In those files, I seem to have written ideas about topics I once intended to write about, books I was planning to write, though, of course, most of those books will never be written and most of those books should never be written. Those files should be deleted. On the other hand, it is good to have those files. Sooner or later, I stumble upon them and realize that I have already forgotten much that at one point, at one period of my life, seemed of great importance to me. These forgotten files and lost bits of mental activity are tremendously sad and deeply disquieting. That's why they should stay there. Tombstones and timebombs of the former self.

There's a question in one of those files, I guess it is a question written to myself, though it is fair to ask who was it really written to? It's a question that simply reads, "Why did Joan Mitchell go to France?" For some reason, instead of many other different books about lots of different subjects I've often planned to write, or felt even somewhat compelled to write, that question about Joan Mitchell has resonated in dark and obscure parts of my mind, of my self, and has forced me to write this book. Because beneath that simple question, Why did Joan Mitchell go to France?, lies the deeper and finally unfathomable question: Who was Joan Mitchell, really?

Preface

There is something strange about Joan Mitchell going off to France. This is not *merely* a surface issue, not an issue simply of a person's particular biography. Joan Mitchell was, at first, an American from Chicago. She tried her hardest to become a painter in America, a great painter. She accomplished that, sort of, but in an incomplete and unsatisfying way. Something was forestalled. A forestalling happened. And then she went to France. And in doing that, she ruined everything she'd been trying to create for herself. Or did she?

Joan Mitchell was, indeed, a truly great painter, in my humble opinion. She was a massive handful of a human being. She was terrible. She was great and she was awful. She behaved monstrously. She was a person so tender, at times, as almost to dissolve. She was a genius, I suppose, whatever that means. Anyway, more than coming to judge her or her life, I have come simply to love her. And I have come to fear her. By looking at her paintings, mostly. By learning really how to look at them, I think. I think I've learned to do that. It took many years and it took genuinely not understanding or being able to look at first. It took a lot of not-knowing, not-seeing, not-getting-it. Finally, I started having the experience of looking at her paintings and really seeing what she was putting there on the canvas. Finally something clicked. It all happened for me because I wondered, "Why did Joan Mitchell go to France?"

In the end, I can only fail to answer this question in any fully satisfying way. That leaves these writings as an interesting document of failing to do something that

Preface

one feels compelled to do even though one knows that it is futile. The very expression of the futility becomes, perhaps, worthy of having been expressed, which is not a bad summary of what Joan Mitchell tried to do with paint on canvas, which she struggled and labored with in many lonely hours before giant white stretches of canvas, in moments when she hovered between being one thing and being another, in the periods, I want to think of them almost as holy, when Joan Mitchell unraveled her self and found something else lingering there in the unaccountable no-space of creation, in the secret and mysterious moments when she came into contact with ... what?

1. One day in 1983 Joan Mitchell started painting a bunch of paintings. You could call them landscapes. Or are they something else? She painted, finally, twenty-one versions of this place that wasn't quite a place. These great paintings are hard to understand.

SOME PEOPLE REFER to them as a suite of twenty-one paintings. I kind of like the sound of that, a suite of paintings. It's an admittedly pretentious way of talking about a bunch of paintings, but it sounds nicer than bunch—a suite. Or better than nice, it sounds like something you could really enjoy. When I hear that there is a suite of something, a suite of amenities, for instance, I always expect enjoyment to be in the offing. If someone is offering you a suite of something, they are pretty confident. There's even something a little cocky about it. When you're offered a suite of something, you don't expect to get crap.

 I doubt, I very much doubt that Joan Mitchell ever referred to any of her paintings with the term "a suite."

The Grand Valley

Joan Mitchell was never given to language like that. Even though she was raised in rather refined circumstances in Chicago and had access to a lot of wealth and luxury throughout her life, she just wasn't like that. A lot of the time, she liked to keep her language and her manner of living pretty rough. She roughed it up, much of the time. Much of the time, she made her life harder than it actually needed to be. She couldn't help it. That was one of the aspects of being Joan Mitchell that could never be helped. There was no help. And whenever help was forthcoming, she generally made a point of not accepting it or even sometimes spitting in the face of help, sometimes literally.

So we probably shouldn't call the works a suite of paintings. Maybe we should call them a series. That is plain enough. A series of paintings. There are twenty-one of them. I've never seen the whole series. I've only seen some of them in person. I doubt that anyone other than Joan Mitchell, and perhaps a few close friends or other people around Joan Mitchell at the time she painted the series, has seen all of them. I don't even know where they all are. Probably some are in private hands and some in museums and some in galleries. They are all over the place, now. No one will ever see all twenty-one of the *La Grande Vallée* paintings, the Grand Valley paintings. Probably it is the case that the full suite of paintings will never exist in the same place ever in the history of the world from now on. Joan Mitchell painted them, during the years of 1983 and a little bit into 1984 she painted them, and then after painting them they

One day in 1983 Joan Mitchell started painting

went out into the world and they will never be together again. She painted this suite of paintings, this series of paintings while living in her hideout, so to speak, while living in a kind of self-imposed exile in a small town in France. She was in her late fifties when she painted that suite, that series of paintings. They are extremely large. There is a lot of color on the paintings, a ton of color on the canvases.

Some of the Grand Valley paintings, the suite of twenty-one paintings, the series, some of them have a lot of blue all over the place. Dabs and jottles and then big sweeping brushstrokes of blue. Lots of blue. Others have a lot of yellow. Orange can be found. The canvases are large. The color is large. There are plenty of drips. Drips of blue, drips of green. Drips of yellow. Joan Mitchell let the paint drip when she made her big brushstrokes on the canvas. Sometimes she put a lot of paint on the brush and sometimes she put less paint on. She varied the amount of paint and she varied the amount of dripping, the wateriness of the paint. Are you getting the idea? I picture her moving a lot and then sort of running at the canvases with her brush and then crouching down and smoking a cigarette and just looking at the canvas for a long time, listening to some music, as she was wont to do, smoking, thinking and looking, or not thinking really, not planning too much, just letting the sense of that color and that need for the next move settle in and then rushing back in at the canvas, making another series of strokes and sweeping gestures at the canvas, making her Grand Valley.

The Grand Valley

But what is this place that Joan Mitchell painted without painting it? I say that she didn't really paint it because Joan Mitchell never painted something as just something. You could look at the suite of paintings known as The Grand Valley and never know that the paintings are of or about a place. You could just see lots of marks of color on big canvases. There's no code for understanding the paintings and there is no map for understanding how the paintings reveal a place. They reveal a place and they also conceal a place. Because the Grand Valley never actually existed. The Grand Valley is a memory. And it is not even her memory. The Grand Valley is someone else's memory, the memory of another person who told Joan Mitchell about the memory. There are layers of distance here. The memory of the Grand Valley might even be the memory of a place that was a fantasy, a child's fantasy. So it is the memory of the fantasy of a place. That might be the truth of it, the real truth of Grand Valley. There's simply no such place as the Grand Valley, you might say, and so these paintings by Joan Mitchell are so far removed from anything specific, any real or concrete thing in the world, that there is no point in thinking about the Grand Valley as a place.

And yet, it is a place. You can know something about the place on that suite of canvases, that series of paintings Joan Mitchell painted in 1983 and also a little bit in 1984. She was in a small town in the north of France, a small town along a bend in the Seine river, a place where the Seine river almost doubles back on

One day in 1983 Joan Mitchell started painting itself, an extremely tiny little village, really, in the central part of northern France not very far from Paris but also very very far from Paris, as such places can be. In this beautiful but also forgotten and tiny and one could say probably quite lonely place in the north of France, Joan Mitchell painted a bunch of paintings, a suite, a series of paintings that are of a place someone else told her about and which itself might not have really existed, or existed as a place only for the games and fantasies of children.

The paintings in this suite, in this series, in this collection of huge canvases filled with all sorts of colors, with so much blue and with areas of yellow and even purple sometimes, these canvases with blue and green and then bursts of color, these canvases were the culmination of Joan Mitchell as a painter, as a person who was a painter, of a particular being-in-the-world that we can name Joan Mitchell but who is also all the forces that so happened to coalesce around the particularity that is the individual entity Joan Mitchell. This person had a way of being and a way of painting and the full force of all of that came out on the canvases, the suite of works, the series of twenty-one paintings called the Grand Valley that are so difficult to describe but so impossible to forget once one has seen a few of them. This person, this Joan Mitchell, must have had her reasons, or must have been following some kind of trajectory, perhaps a kind of fate that led her into becoming the version of herself that painted those paintings, that suite of paintings, that series of twenty-one canvases that could have

The Grand Valley

only been painted, that were actually and only painted in a small town in the north of France where a woman from Chicago ended up, many years later, in her late fifties, suddenly able to paint this remarkable suite, this remarkable offering of color and memory and place and movement and shape and feeling and blues and other brighter colors and areas of white and large spaces and emotions difficult to express with any specific words.

2. We are introduced further to Joan Mitchell and to the puzzles and mysteries of Joan Mitchell and that leads to a more general discussion of difficult people and what makes them also wonderful.

WHAT CAN'T BE emphasized enough is her violence and her anger, drunken much of the time, yes, but also stone-cold sober sometimes too. Her rage. Her fury at the fact that painting exists at all and, seemingly, a special fury reserved for her own. She wanted to smash her paintings to pieces and sometimes she did. And then she went to France. Of course, lots of people go to France all the time and nobody declares this particularly interesting. But Joan Mitchell is not supposed to go to France. How could she learn anything in France? She's of the wrong generation after all. At different times in American history Americans go to France. It's practically required. There, in France, they learn something about art or life or politics and they bring it back to America. Thomas Jefferson and Benjamin Franklin, for instance, go to France. And it works, all in all. It is right for those guys to go to France. Everyone admires people

like Benjamin Franklin and Thomas Jefferson for going to France and getting that essential French thing that was needed at just the right time and then bringing it back to America, and somehow being American just how they need to be American and neither being too French nor not enough French. Just right.

Also, Gertude Stein and Alice B. Toklas go to France. Basically, they never come back to America. For all practical purposes, they become completely French. Except that no one ever thinks of Stein and Toklas as French. They are Americans in Paris. All the Americans are in Paris between the wars. That was the time to be in France, in Paris. There are stupid movies about this. In a funny way, it was almost as if France was the place where you could be more American than anywhere else for a couple of decades. Maybe this was the secret of France for that generation, the so-called Lost Generation. You didn't know where to be. You were lost, for Christ's sake. You didn't know how to be an American nor, perhaps more crucially, where to be an American. And somehow, in France, it seemed that one could be this not-knowing sort of American better and more authentically than anywhere else. Paris solved the problem of how to be an American when America didn't seem to be the place where one could be an American anymore. This is a strange problem. It also has to do, especially, with art and artists somehow.

The mystery of Joan Mitchell, however, is the mystery of a person who went to France for all the wrong reasons at all the wrong times. Because things change.

We are introduced further to Joan Mitchell

After WWII, you could be an American in America again. There are surely deep and complicated reasons for all of this, for the shifting in possibility, for the fact that at one time you can be an American in America and at another time you can't and then another time you can again. We'll never sort out all the reasons or understand all the very subtle layers of this phenomenon of shifting Americanness. Perhaps it is simply that a few influential persons, persons like Stein and Toklas, demonstrate a certain way of being an American not in America, and then it's like an avalanche and everyone else piles on. Never knowing exactly why. By WWII, the avalanche was going in the opposite direction. If you were an artist, especially, very much especially if you were a painter and extra special double especially if you were an American painter, even if you were an American painter who was born in Armenia or Holland or wherever, but if you were painting in the American style, with a certain commitment to an expressive form of abstraction, then you were more or less required to be in New York City in the post-war era. We don't get to choose these things willy nilly. They happen. History makes them happen and woe to the person who thinks they are bigger than history. That's a way to get crushed. That's a way to get cast aside. Cast away. Destroyed.

But Joan Mitchell was stubborn and angry. She zigged in a time of zagging. She courted destruction by willfully going back to France over and over again when there was nothing for her there. The times said that she must be in New York and she said no. She denied

history and sense. That is the mystery. Why did she do it? What was she after? What was her problem? What was driving her, what problem in paint and canvas and looking thrust her out into a dangerous denial of the general direction of the historical avalanche? There are other mysteries wrapped up in this one mystery, other problems, other puzzles. I'm not sure any of them can be solved. I can't solve them. I only peck at them. I only burrow.

Why was Joan Mitchell so angry? That's another mystery. Some people are just angrier than other people, it must be said. Some people go through life with a barely contained fury. Some people are combustible. I like that word, because it speaks of the suddenness and the explosion by which the persons who are angry in potential become angry in actuality. Some people walk around with a thinly contained combustibility and you can almost feel it crackling on the skin-surface of the people who are like that. Violence is there. I don't mean the violence of hitting and punching and kicking, though this kind of violence certainly exists amongst the combustible. But perhaps more disturbing than the actual violence of hitting and kicking and biting is—I don't know, what is it? Also the biting is pretty bad, it should be said. I can picture a scene, say, in the East Village in New York City where Joan Mitchell is walking down the street with someone, some anonymous male person tangentially connected to the artworld of the time, and then this person says something and then something in Joan Mitchell's mind or person or soul is

We are introduced further to Joan Mitchell

set off and she just turns on the street right there and grabs the male person's arm and just bites into it, not a playful bite, not a controlled warning bite, but a full-on plunge-down-and-through-the skin-of-the-arm sort of bite. A bite that wants to rend flesh from flesh. A bite that draws blood, real blood, mouthfuls of blood. I'm not saying this ever happened, by the way. Joan Mitchell was not known especially for being a biter, though she did bite a couple of people, I'm pretty sure. I think she bit Jean-Paul Riopelle a couple of times, but we'll get into Jean-Paul later. More than biting, she was a thrower. She'd throw a hard thing right at your head from a short distance, as hard as she could. She was trying to brain people in those moments. She was a kicker and she was famously, in at least one instance, a testicle grabber, a crunch-the-balls-in-the-hand sort of person. It takes a certain kind of person to grab someone else's balls and squeeze them hard. Especially someone you don't know. Just to grab those balls and squeeze them, the softness of them, squeeze down into the pain. To watch the fear and surprise in the person's eyes as you squeeze the balls. So, the point is that you can see the scene on the street in New York City quite clearly. You can feel the electricity and the fear and the pheromones in the air as she chomps down. You can smell the street, the specific smell of the streets of New York City late at night when you're walking along in the humidity of the simmering city and you've had too much to drink and you think something is supposed to happen but you're not sure what that is.

The Grand Valley

Still, can it be said that the scariest times, when you are with the combustible folk, are the times when the person hasn't quite erupted? Maybe they will. Maybe they won't. You don't know for sure. You can't know for sure. The combustibles are not a people given to clear signs. Sometimes, of course, you know. Sometimes the combustibles have reached that point where the eruption is going to happen and there's no doubt, so you just batten down the hatches, as it were, and ready yourself for the explosion that will come without a doubt. But this doesn't happen all the time. Not even most of the time. A true combustible is unpredictable. That's part of the power that a combustible wields. The unpredictability is part of it. The combustibles know this in some part of their being. I'm not saying that they plan it or that they are even in control at all, even a little bit. But some part of their being is aware, nonetheless. Some part knows. Be unpredictable. Explode one day when there is no reason at all, when none of the predictable variables were present at all. Then, another day, face all the otherwise predictable factors, the types of things that normally set you off, and do nothing. A top-notch combustible will do both of these things. They know it is necessary in some deeply recessed part of their being. To be a combustible is to keep everyone on notice all the time, even yourself, especially, perhaps, yourself. There have been terms over the years that attempt to express what this kind of person is like. A live wire. People say that, so-and-so is a live wire. I like that phrase, live wire. Some people are live wires.

We are introduced further to Joan Mitchell

There is a specific state of being that is created by the combustibles. They create it in themselves, but they also project it onto the persons around them because of the way a person like that is always buzzing and humming and always emitting the possibility that the eruption might happen. They project a certain state of being into the world. It is physical and it is also metaphysical. You know what it is like. I don't have to define it for you. I don't have to try to force words too much here, do I? People like that are terrible and being around them can be so terrible. People like that are also wonderful. Thank God for people like that.

3. The pain and difficulty of Joan Mitchell's paintings, which can be very difficult and painful indeed. The difficulty of people who show things by hiding and vice versa, people like, for instance, Gertrude Stein and Alice B. Toklas.

EVERYONE WHO FIRST looks at a painting by Joan Mitchell, at any sort of painting by the mature Joan Mitchell, the Joan Mitchell who'd finally learned how to paint the Joan Mitchell way, which happened roughly in 1953, and perhaps on one specific canvas, one specific painting that is simply titled *Painting*, the first painting that is really and truly and actually a Joan Mitchell painting, and almost every single painting that Joan Mitchell painted from that day in 1953 until her death in 1992, gets a punch in the eye and a kick in the teeth. Even the Grand Valley paintings, which do seem to contain some simmering and difficult-to-pinpoint calm wisdom, you might say, even the calm and yet still crackling energy of the Grand Valley paintings have an element of this danger. You look at any canvas painted by Joan Mitchell and it reacts back at you. That's the

The pain and difficulty of Joan Mitchell's paintings

thing. The paintings do not just receive the eye. They receive the eye and then they come right back. Right in your eye. A hard object thrown at your eye and meant to injure that eye. The paintings of Joan Mitchell are, in this sense, injurious. They are injurious paintings created by an injurious combustible. Joan Mitchell said, it should be noted, on a number of different occasions she made it clear that she had no interest in making ugly things, that she wasn't trying to make offensive work. And that's true. The work is not ugly. But it is injurious. There's more, of course. Sure, indeed, there are plenty of experiences one can have looking at Joan Mitchell paintings. If they were paintings of injury and nothing more they wouldn't be worth all that much. I mean, I'd respect a painter who could paint injury paintings that injured the eye canvas after canvas. That'd be quite an accomplishment, actually. But that's not Joan Mitchell's accomplishment. Joan Mitchell created injurious canvases but they are also more than that. They go far beyond the injury and the hurt.

But they start there. Commentators on Joan Mitchell tend to avoid this simple fact and why would they not? Who wants to start in injury and hurt? Who among us seeks out the combustibles by choice? Who among us? So, the commentators do the work of taming these canvases, taming them and putting them down. Go to bed, hurtful canvases. Calm down. We will calm you down. We will pacify you. We will smooth out the bumps and bruises.

The Grand Valley

Bruise. That is a word. That is a word that must come back out to the surface, no pun intended, in looking at the canvases of Joan Mitchell. All the bruises. Each canvas a kind of bruise. And why not bruises? A person who is a hitter and kicker and even sometimes a biter, a person who lets the violence erupt and who goes beyond the fear and hesitation and the social mores that prevent us, most of the time, from striking out, a person who lets the blow fall and delivers the blow, a person who breaks the boundary between the fear of violence and the actuality of violence, a blow-dealer and a blow-seeker, this sort of person is also a person of the bruise. Just look at a Joan Mitchell canvas. Just pick one at random. And then think of the word bruise. You know that I am right. You see it. Each painting a bruise. Of course, there is more. But let's dwell in the bruise first, if we may. Let's allow each painting to be the bruise that it is.

Joan Mitchell is a painter at war with the world. But even that doesn't say it. She is at war with something more than the world. What is she at war with? Does she know? Does she even know what she is battling? Just what is the battle of which her bruised paintings are the battlefield testimony? Can we know?

There is a film. This film contains very little information about Joan Mitchell, at least on the surface. It is an enigma, that film. It shows us Joan Mitchell talking about art sometimes. But Joan Mitchell hated talking about art and hated trying to explain her paintings. So, it shows us Joan Mitchell in the mode of hate. It shows us Joan Mitchell trying to avoid a bunch of different

The pain and difficulty of Joan Mitchell's paintings

questions and Joan Mitchell trying to put on various poses and Joan Mitchell hiding as much as she can even as she sits or stands in front of the camera that is supposed to reveal. The film is supposed to reveal something about Joan Mitchell and instead, because Joan Mitchell just won't have it, the film is probably one of the more obscuring documents of an artist you're ever going to find. The film is called *Joan Mitchell: Portrait of an Abstract Artist* and it was made by a woman named Marion Cajori but, in fact, it is not a portrait at all. It portrays very little or even nothing. It's the opposite of a portrait or maybe, better said, it is a negative portrait. It says something about Joan Mitchell by showing all the things that can't be said about Joan Mitchell. It shows Joan Mitchell as completely incapable of showing herself or of revealing what it is that she is doing, the abstract painter.

Which makes me think, again, of Gertrude Stein and Alice B. Toklas, since one of the funniest and least revealing autobiographies ever written is *The Autobiography of Alice B. Toklas*. Indeed, these two works of art, biography, whatever they are, these two works of reflection from one person onto another, *Joan Mitchell: Portrait of an Abstract Painter* and *The Autobiography of Alice B. Toklas* are very similar in that they conceal far more than they reveal. Or the revelation, insofar as there is a revelation, is packaged within the structure of a concealment. It is by the stuff we don't learn that we slowly begin to learn the stuff we must learn, which is not and cannot be on the surface anyway. Whatever we're going

to learn about Alice B. Toklas (but is it really Alice B. Toklas we are learning about in the autobiography that is written not by the actual "auto," the self, of the autobiography but actually by Gertrude Stein, who is not, ostensibly, the subject of the autobiography at all, but who, as everyone who is paying any attention already knows is, in fact, not-so-secretly the actual subject of the autobiography, the point being that the trickiest thing that Gertrude Stein maybe ever did, and she did lots of tricky things, was to write an autobiography of herself by writing an autobiography of someone else?) whatever we might learn about Alice B. Toklas and about Joan Mitchell in the works that are supposed to be some revelation of these two persons as the sort of persons that they are, this revealing is, in fact, largely going to be about obscuring and about circumventing any kind of direct knowledge and is therefore going to prod us on, at least those of us who take the hint, who are willing to be pulled along by the thread of a mystery, it's going to prod us along into seeing something that cannot be looked at straightaway, cannot be confronted head on, as it were, and is only going to be shown by a certain sort of not-showing-directly kind of obliqueness that seems to be crucial, in ways we don't properly understand yet, to the kind of persons, the kinds of artists that were, in this case, Alice B. Toklas (Gertrude Stein) and Joan Mitchell.

We have to assume that Gertrude Stein loved Alice B. Toklas very much and that this love held them together and bonded them together for most of their lives.

The pain and difficulty of Joan Mitchell's paintings

I say most of their lives but, in fact, Gertrude Stein died in 1946, died of a very terrible case of stomach cancer, though I suppose there is not really such a thing as a great or a nice case of stomach cancer, stomach cancer being one of those things that just isn't looked forward to by anyone, as far as I'm aware, and after this quite lousy episode of stomach cancer Gertrude Stein just up and died during a surgical process that was intended to cure her stomach cancer but in fact did pretty much the opposite, which was to kill her dead. Alice B. Toklas, however, lived on and on after that and did not die until 1967 at which point she was, as the reports often put it, living in some state of more or less dire poverty, having been prevented, through stipulations of Gertrude Stein's last will and testament that were manipulated, as such things are, by the various relatives of Gertrude Stein who had their own ideas about where all this money should go, namely to themselves, from selling any of the very expensive Post-Impressionist paintings that Stein and Toklas had amassed and so, bizarrely, despite the great love of Gertrude Stein, forced to live on and on in increasing misery and isolation and neglect and poverty while surrounded by an immense wealth hanging on the walls as she constantly thought about her old love Gertrude Stein and claimed that her only purpose in life was to protect and serve and veritably worship the memory and legacy of her great love Gertrude Stein until finally, one wants to say mercifully, she, Alice B. Toklas, finally got to die too and was buried, not quite

having reached the age of ninety, in a cemetery in Paris right next to the love of her life, Gertrude Stein.

This is a great love affair nonetheless, the love affair between Gertrude Stein and Alice B. Toklas, and we can understand that Gertrude Stein wanted to pay some tribute and to bring some illumination to the life of Alice B. Toklas, the love of her life, and so she, Gertrude Stein, decided finally to write about Alice B. Toklas, and because Gertrude Stein was Gertrude Stein she hit upon the dangerous and one might even say mocking, or at least the certainly prodding and provocative idea of not just writing about Alice B. Toklas but, in fact, the autobiography of Alice B. Toklas, and being so cheeky in writing this autobiography she would, in fact, go so far even as to sign this autobiography with her own name, to say openly that yes, indeed, I Gertrude Stein have written the autobiography of Alice B. Toklas.

It could be said, of course, that this very idea, the idea that Gertrude Stein could write the autobiography of Alice B. Toklas, was itself a tribute to the intensity and to the merging, the fusing of souls that was the love affair between Gertrude Stein and Alice B. Toklas, and there may in fact be a good deal of truth to this idea. It cannot be, however, the full truth of the matter since the actual book, *The Autobiography of Alice B. Toklas*, it is fair to say, is not an especially revealing book about the person or character or the life story of Alice B. Toklas. In fact, *The Autobiography of Alice B. Toklas* is overwhelmingly dominated by discussions of Gertrude Stein, what Gertrude Stein has been doing, how she interacts with

The pain and difficulty of Joan Mitchell's paintings

Pablo Picasso, what Gertrude Stein likes and doesn't like, who Gertrude Stein likes and doesn't like, what Matisse is doing on any particular day and what Gertrude Stein happens to think about what Matisse or Picasso are doing on any particular day. The book, as we probably suspected it would be, is overwhelmingly about Gertrude Stein. This, again, is no great surprise. We know that Gertrude Stein, in being so cheeky and even outrageous as to write a book called *The Autobiography of Alice B. Toklas*, was, in a more or less amusing way, going to write something that was in no way an autobiography of Alice B. Toklas. How could she, after all? Gertrude Stein, for all her deep insights, for all her intimate knowledge of Alice B. Toklas, was actually not, we can all admit, was in no way herself Alice B. Toklas. Gertrude Stein was Gertrude Stein was Gertrude Stein and Alice B. Toklas was Alice B. Toklas. Gertrude Stein's autobiography of Alice B. Toklas is therefore, inevitably, going to tell us a heck of a lot more about Gertrude Stein than it is going to tell us about Alice B. Toklas. This is, in fact, exactly the case. The book is yet another excuse for Gertrude Stein to talk about Gertrude Stein, which is what she does.

But even that is not so simple for the simple reason that *The Autobiography of Alice B. Toklas* by Gertrude Stein is also not very revealing about Gertrude Stein. I mean, Gertrude Stein is evoked constantly throughout the book. We are told countless facts about Gertrude Stein. We are told about what she is doing and how she feels. And yet, I defy anyone to read *The Autobiography*

of Alice B. Toklas and then to relate anything that they've especially learned either about Alice B. Toklas—since there is next to nothing that gives one a grasp of Alice B. Toklas as we've already mentioned—or moreover, for that matter, and perhaps somewhat more surprisingly, about Gertrude Stein, who we all realized was, in fact, the real subject of the autobiography. One has the distinct impression, actually, after reading *The Autobiography of Alice B. Toklas*, that the book is about nobody. That it is about nothing.

So why would Gertrude Stein write an autobiography of Alice B. Toklas, which is in fact a book about herself, Gertrude Stein, which is really actually a book about no one and which reveals next to nothing about anything? It's pretty funny. But funny in a disturbing way the more you think about it. It's also clear that Gertrude Stein was fully aware of the funny/disturbing thing she had done. At the end of *The Autobiography of Alice B. Toklas*, Gertrude Stein teasingly, she actually uses the word "tease," teasingly tells the story of how the book came to be, about how people hounded Gertrude Stein to write her autobiography and how she didn't want to do it (why?), and then turns around and starts hounding Alice B. Toklas to write her own autobiography until, finally, after both women realize that Alice B. Toklas is "pretty good" at a bunch of things but probably wouldn't be pretty good at being an author, Gertrude Stein finally decided to write the autobiography for her, for Alice B. Toklas, and that she will write this autobiography very simply and with the kind of

straightforwardness with which Defoe wrote the autobiography of Robinson Crusoe, which, when you come to think on it, is an especially funny and incredible thing to say since Defoe's book is about a person who exists only as a fiction and who barely exists even as that, being more or less an empty vessel, Robinson Crusoe that is, an empty vessel for all the stories about survival and self-sufficiency that Defoe was going to concoct and, come to think of it, the "self-sufficiency" of Robinson Crusoe is quite a crazy self-abnegating self-sufficiency since the very means Robinson Crusoe uses to survive and to become self-sufficient on his little island are the techniques and tools by which he evacuates himself as a self, puts all of his attention into the project of survival, which is the only thing we really learn about Robinson Crusoe in the book. He has no inner self. Also, there is Friday, the indigenous person that Crusoe takes on as a kind of servant. But we cannot get into Friday right now. That would be too much.

My point being here is that no one reads *Robinson Crusoe* to gain deep insights into the person Robinson Crusoe, who never actually existed anyway, not that this matters so much since many non-existing persons are the most interesting persons in the world, but still, in this case, Robinson Crusoe is not a person with much of a personhood really, we might say, and is only interesting for the purpose of hanging the story on the person, as it were. The point of the novel is to describe what Robinson Crusoe does and how he manages to survive in his situation and that is why the novel is interesting.

The Grand Valley

It is not a novel about Robinson Crusoe himself (but what exactly is that?) and we learn very little and do not in any way feel that we really "know the man," as people say, at any point in the book. That this book is often considered the first novel is therefore quite an amusing and perplexing fact, since novels are supposed to be the first form of literature that allows us fully to explore the interior life of the individual person. But the inner life of Robinson Crusoe seems to consist primarily in the desire to figure out how to have an outer life, that's to say, how to survive.

So this, anyway and for what it's worth, is the very novel that Gertrude Stein references in her closing of the book *The Autobiography of Alice B. Toklas*, and this very fact, it is safe to say, shows us that Gertrude Stein was well aware that she was poking at some deep perplexities in what it means to explore the "interior life" of individual persons and that, in some sense hard to articulate exactly, Gertrude Stein wrote a book that denies the possibility of doing either of these things under the very guise of doing the very thing that the book goes on to show us it isn't going to do and, moreover, calls into question can possibly be done anyway.

Sneakily, Gertrude Stein wrote an autobiography of Alice B. Toklas in order to write an autobiography of herself. But even more sneakily, she wrote an autobiography of Alice B. Toklas in order to write an autobiography of herself that reveals there is nothing to write an autobiography about.

4. Joan Mitchell was an abstract painter, more or less. But what is that, really? What were mid-twentieth century abstract painters trying to do? What was Joan Mitchell, specifically, trying to do with abstraction and, also, isn't it interesting to talk about Clyfford Still sometimes?

ONE OF THE THINGS one can notice in looking at the canvases of Joan Mitchell is that they don't hold the canvas in the way that other sorts of paintings in the broad category of abstract painting, that sort of expressionistic, postwar New York School of painting or whatever you want to call it, the legacy and the tradition of painting out of which Joan Mitchell emerged, but from which she also interestingly diverged, and diverged in one important way in that those paintings often hold the whole canvas in the way that many Joan Mitchell paintings do not . . . hold the canvas, that is. Indeed, the paintings of all those sorts of American painters in the immediate postwar era, the paintings of the so-called

Abstract Expressionists that finally gave Joan Mitchell the language and technique and basic approach to the canvas allowed her to go on, to become a painter, to find her own specific voice, to get a style, however you want to describe it. Still, when you look at a lot of those other painters you'd say that these paintings try to make sense of the whole canvas. They have a certain complete, entire-canvas sort of feeling, if you know what I mean, like they're trying to make sense of the entire stretch of canvas, the entire square or rectangle or whatever it is. Many Abstract Expressionist paintings are the sorts of painting that don't want to leave any part of the empty surface of the canvas unaddressed. They don't want to seem like they forgot to put a mark anywhere. That's probably a deep fear at the heart of all abstract painting, the fear that the whole thing is just downright arbitrary. And, of course, to some degree it is. The beautiful thing about abstract painting, especially in its so-called "expressionist" variant, is that there is nothing definitive being portrayed. A great abstract painter is therefore a painter that can make something completely arbitrary and without any clear referent or meaning or purpose, feel completely filled with reference and meaning and purpose, but just barely, or even indefinably, so that the painting never completely resolves into anything in particular, and therefore becomes all the more hoveringly, painfully significant just for the very reason that it is so hard to say exactly why the damn thing is so significant. And that's also why so many of these sorts of painters want to make sure that they've done something to every

Joan Mitchell was an abstract painter, more or less

bit of the painting. They want to be sure that we get it. The painter has to prove that they meant to do this. It was intentional. There may be something arbitrary here, but it isn't random. Or if it is random, the very randomness transforms into significance and importance. Intentionality has emerged, maybe in the very act of casting it aside. And that's quite something, say the abstract painters. Holy shit, they seem to be saying, you cast everything aside and then here it is, this painting, which seems arbitrary and pointless and gives no clues as to how it should be viewed. And still, nevertheless, even with all the casting-away, reference and meaning and purpose is all over the surface, smeared out maybe, hiding in plain sight, but all over the canvas so much so that it might make you gasp.

Joan Mitchell looked at and learned about all these sorts of paintings during the time that she herself was a young painter trying to figure out how she could do her own version of what these other cast-awayers and canvas-fillers were doing. But she also brushed certain things aside, no pun intended. First off, she pretty much brushed Jackson Pollock aside since Joan Mitchell never really liked or was moved by or learned much from Jackson Pollock. Not really. She was never going to put that much paint on a canvas. She just wasn't going to use that much paint, plain and simple. I think she looked at those Jackson Pollock paintings and just felt immediately annoyed. Jesus, man, why are you using so much paint and drooling over every inch of the canvas like that, she no doubt said to herself. Can't you leave even an inch of

that canvas alone? Can't you back off a bit? Joan Mitchell was simply never going to be a paint slathering Jackson Pollock sort of person. She wasn't in love with paint as a substance, as a sticky thing to throw around, in the way that Pollock was. She liked paintbrushes much more than Pollock also, the different techniques that different brushes demanded. She liked paintbrushes in all shapes and sizes and thicknesses and thinnesses. She was in love with color, yes, she was in love with paint because paint is the thing that has the color. But that's an entirely different thing. Entirely different. She was obsessed with color and because of that, paint, for Mitchell, was deeply exciting only because paint can hold and also transfer color. That's what so many of her canvases show us. Look how color does this here and then, thwack! changes all around right over here and then carries forth this mood and this feeling here, and then just peters out and the painting is done. That was enough for Joan Mitchell. Get some color happening on a few important spots on a canvas and that's it. Let it be. Don't cover every spot. Don't think about the canvas as a problem that has to be solved completely. Think about it as a place where color happens and don't frickin' kid yourself that you're ever going to "solve" anything. Color happens, especially up against other colors, and with all kinds of moving lines and strokes and daubs. That is more than enough. That is everything. Any of the other so-called Abstract Expressionist painters got into this territory of a certain restraint. Some even left good portions of the canvas well-enough alone. But did

Joan Mitchell was an abstract painter, more or less

any of them have quite the powers of explosion and restraint that Joan Mitchell had? I don't think so.

Even Clyfford Still. Even Clyfford Still was not quite like Joan Mitchell. I bring up Clyfford Still because he was interested in breakages and discontinuities within the painting. He wasn't drooling all over the canvas like Jackson Pollock. He was interested in paintings that fall apart and come back together again, and in jagged edges and in puzzle pieces that aren't even in the same puzzle, and in baffling areas where nothing is going on at all. Can we say that about a Clyfford Still canvas? He found it interesting and amusing to make a painting that just stops in the middle, in its own middle. It is a kind of resistance, is it not? I'm not going to put all the parts together here, he seems to be saying, or better yet he just shows that. He lets a sense of the crazy arbitrariness of abstract painting stay right there on the canvas. He is brave enough to do that. He realizes that the restraint makes the other places of color and shape all the more resonant.

One of my favorite Clyfford Still paintings is *1965 (PH-578)*, which he painted, you guessed it, in 1965. I like *1965 (PH-578)* because it's a real Fuck You painting. The title already prepares us for that. This is not a friendly title. It's less a title and more of a label. It is like the card by which you would mark something at a natural history museum, which is how, in some ways, the painting feels to me. When I look at *1965 (PH-578)*, I always start to think about continental drift. The geologists tell us that the seven continents were once all together in the

middle, millions and millions of years ago, and they've named this big, primordial continent-glob Pangea. This was how things sat in the late Paleozoic era. Later the big chunky supercontinent broke up and all the bits started floating off in every direction. Who knows why? They couldn't keep it together. The continents drifted off and now it's how it is now. But you can see that it was once all one big glompy continental Pangea-thing because of how South America obviously tucks in there right into Africa, basically spooning with Africa, and North America nuzzles into the top of Africa and smooshes Europe in there and Australia cozies up on the other side. Just look at a world map and you see the evidence of all this prehistoric spooning and cuddling.

A memory of the spooning and cuddling of continents is there in 1965 (PH-578). But the naughty thing that Clyfford Still has done is to take away the fitty parts. These amorphous shapes of color seem like they want to fit together but they also do not. Well, not completely, actually. There is the sense of a possible fitting together with the patch of white and two patches of brown and a patch of blue and the intriguing little patch of ochre, or whatever it is, up at the top. There are hints of a fitting. But the closer you look at it, the more you see that it's just not going to work. They don't really fit, those parts. They do and they don't. There's a dream, somehow, in the painting, a kind of utopian suggestion that in some other universe these guys might have had the chance of getting together. But here, they don't. On this canvas, we realize the impossibility of it. The gaps between the

patches are decisive here. The gaps are as much a part of the painting as the patches of color. The thing that holds the painting together is that there is nothing to hold the painting together. Somehow it is brilliant, isn't it, that there are two patches of brown? The one thing you wouldn't want twice is the brown. Why not the blue? It's so pretty! Why not more ochre? It's so interesting! Clyfford acknowledges that we are suckers for the ochre by giving us a dab of it on the white. He knows what we want. He teases us with the dab of ochre on the white. Devilish! But he's not giving it to us. He's not giving it with the fitting-together and he's not giving it with the color patches. In fact, Clyfford is so annoyed with our dumb and cheap eyes, our pretty, blue-wanting and interesting, ochre-wanting eyes that he doubles the brown. It is crueler, this double-brown than any all-brown painting could ever be. An all-brown painting could simply be ignored or, alternately, approached with the dirty thrill of the abject. Clyfford doesn't want us to have it so easy. He creates areas of lovely blue and thrilling ochre and then blasts us with double brown. Boom, take that. The dream of Pangea fades. The fantasy of unity lost, it's never coming back. The Garden is now forbidden and Uriel guards the entrance with a flaming sword.

1965 (PH-578) is, thus, an achingly sad painting. Once you get to really looking at it that's what you'll see, I promise. It's a Fuck You but it is also crying. The Fuck You is being said through tears, which is, of course,

the true mode in which any genuine Fuck You is always being delivered.

But the kind of crying that is going on in Clyfford Still's Fuck You painting is not a whimpering. It is angry crying, if you want to call it that. Though beneath the anger is something different. Beneath the anger is the sense that every painting is a kind of tragedy and a kind of failure. Could we say, please, that Joan Mitchell's paintings are crying in that sort of way? Not that Joan Mitchell was particularly into crying, or sniveling, or whining as she sometimes put it. She had little patience for whining. Doing anything that could be interpreted as whining around Joan Mitchell was a good way to get hurt. She was going to hurt your feelings. With words most likely. But possibly also she was going to throw an object at your head. Depending on how drunk she was, she might have come after you with something deadlier, something sharper. To be a whiner was to meet with the contempt of Joan Mitchell and meeting with the contempt of Joan Mitchell was going to be an unpleasant affair. Maybe you would end up bloodied and on the floor. Always a possibility. To have one's ass kicked by Joan Mitchell. No, she was not interested in the display of emotion for emotion's sake. She was tough in her dealings with people and toughest of all, probably, in her dealings with herself.

But Joan Mitchell's paintings are crying in the sense that they are always conscious of their own insufficiency. Of course, there is something poignant in the expression of that very insufficiency. Hello, I'm sorry, I'm

Joan Mitchell was an abstract painter, more or less insufficient. That's the basic statement on the surface of any Joan Mitchell painting and is also another way of saying that the paintings are injurious and bruised. I am a wounded insufficiency, the paintings declare. They are canvases that point to themselves and declare, this is insufficient, but here it is anyway. This canvas does not show what it must show. But it shows that, at least. It shows that it is aware of its own incapacity to show and in showing its incapacity shows us something about what can be shown and what cannot be shown. And in the end, by showing and not showing in that way, by crying in anger in the way that a Joan Mitchell painting cries out in anger, it does show us something after all.

I suspect this is why so many Joan Mitchell paintings—the greatest of Joan Mitchell's paintings in my personal opinion—are always unwilling to go all the way to the edges or to clear up all the gaps or empty spots that might happen here and there across the canvas. One of the things about Joan Mitchell's painting in the early days, in the days before she had fully figured out what a Joan Mitchell painting was going to be and how it was going to feel, in those early days in the late 1940s and the early 1950s and really until she truly figured out how to be Joan Mitchell in the late 1950s and into the early 1960, in those early versions of Joan Mitchell struggling to be Joan Mitchell, you see canvases that are trying to make a picture by taking up the whole canvas with the structure and the composition and whatever it was that she was trying to get down there on the picture plane. In short, she is still doing too much.

The Grand Valley

But when Joan Mitchell really snaps into place as Joan Mitchell, she just stops giving a shit about all that. The canvas becomes a place to get something out and leave it at that, however it gets out. There isn't going to be a lot of work to take care of the rest of the canvas. That's not my problem, she seems to be saying. Something happens in one spot of the canvas, generally more or less in the middle, and then she has no apologies for the fact that whatever happened there more or less in the middle of the canvas can't be bothered with whatever is left in the empty spaces of the rest of the canvas. She's not dealing with the canvas as a problem. Lots of painters at that time were worried about that big stupid stretch of canvas, you see. You can grasp the problem, I hope. Here's this stretch of canvas, it's five feet by four feet of stretched canvas (Joan Mitchell always liked to work on a bigger scale) and, well, that's a big challenge. How do you deal with it? How do you deal with the arbitrary nature of that shape, that specific dimension? How do you address the fact that there's no especially good reason why the canvas is five feet by four feet or whatever?

That's why Ad Reinhardt got into perfect squares, by the way, perfect squares painted completely black. Get rid of the arbitrary quality. The embarrassing choices. Drive the choices out of the process. Get to necessity and drive out all the bullshit and composition. Other painters tried to create the sense that the painting could very well extend out to infinity and this is just a little glimpse of that infinity. The frame is just one possible

Joan Mitchell was an abstract painter, more or less framing of an infinite space of color and shape going on, potentially, forever. That's why so many Abstract Expressionists projected the sense that the painting is bigger than the arbitrary boundaries of the frame. I could really just paint this thing out into infinite space if I wanted, they are saying. But I am finite, so I give you a finite slice of infinity. That's what tons of the Ab Ex painters seem to be saying. A kind of bravado of the infinite. I'm in touch with the infinite here, they are saying, and I will deign to give you an itty bitty slice of it. I'm gifting you this slice of the absolute out of the endless depths of my profundity.

We are speaking here, I guess, in the voice of Barnett Newman more than anyone else here. Others too. But Newman talks this way on his canvases. Or, on the other side, some painters get into a sort of playful acknowledging of the arbitrary limit of the frame. I'll do as much as I possibly can within this arbitrary limit of this rectangle, some painters seem to be saying. I'll pose for myself and solve for myself every possible problem of shape and color and form right in here, since that's the space I've got. Brice Marden, for instance, did that. Some painters are real virtuosos in this regard. They take an arbitrary space of stretched canvas and show how much interesting stuff can go on in just that space. They swish and dab and poke and drip and splash and have a grand old time within the formal constraints so arbitrarily handed to them. They have a wild party right there in the rectangle. They bounce around between the freedom of the abstraction and the formal limits of the

frame. This is something that different sorts of abstract painters do and it's a damn sight to behold when it's performed at the highest levels.

But Joan Mitchell did a different thing, I'd say. Instead of tackling the frame or solving the problem of the frame or extending beyond the frame or acknowledging the frame, instead of any of those things what Joan Mitchell did was just to stop giving a shit about the frame altogether. For Joan Mitchell, the big stretch of empty space in the middle of the stretched canvas of whatever size, that bit of space was an opportunity, not a problem. It was an opportunity for something to happen. A painting by the mature Joan Mitchell either works or doesn't work to the degree that something of substance either happens or it doesn't. If it happens, the painting works. If it doesn't happen, it doesn't work. That's it. Well, actually, if nothing managed to happen on the canvas, Joan Mitchell might also just get mad. Then she might rip the fucking thing to shreds with a knife and a hammer and throw it out the window. Always a possibility with Joan Mitchell.

But whatever happens in a Joan Mitchell painting, the paintings definitely aren't going to "solve" the problem of the canvas and have no interest in doing so. By the late 1950s, Joan Mitchell had come to terms with the canvas and whatever shape or size that canvas happened to be. The canvas was no longer setting the terms. It wasn't something she had to reckon with as such. She'd abandoned any concern with what many other Abstract

Joan Mitchell was an abstract painter, more or less

Expressionists had concerned themselves with. She was interested in something else.

5. What is a landscape? What is a crucifixion scene? And why did John Ashbery know so much about what Joan Mitchell was doing and why she went to France?

THERE'S A VERY funny Joan Mitchell painting from 1963 called *Girolata Triptych*. It's a triptych, obviously. The painting is probably just a landscape, in this case a kind of seascape. I say "just" but, of course, the thing that Joan Mitchell did with landscape is one of the more crucial and astounding things she did in her painting career. We'll talk about this more later. For now, suffice it to say that the painting is probably a landscape more than anything. But it is also a European painting. It is a classic European triptych, like something by Rogier van der Weyden or someone. Anyone. You know, a classic crucifixion triptych by anyone. And what do you have in a classic crucifixion scene? You've got Christ in the middle and he's gotta be up there on the cross. Life was simple in many ways if you were a European painter of the late Middle Ages. You take Christ. You put him on a cross. Done.

What is a landscape? What is a crucifixion scene?

But then you've got a panel on either side of Christ to deal with. You've got to put something on the two outside panels. There's only one Christ, so you've got a bit of a problem there. The Gospel stories provide one possible solution. You could put the so-called thieves on the other panels. Some painters do this. I, personally, find this to be a pretty brave option, since you are giving a heck of a lot of space to thievery. And that is probably also why most painters reject this option. They get nervous about featuring so much thievery and they chicken out. But if you chicken out in the face of the thieves, you're back in the thicket of a nasty formal dilemma. What to do with the other two panels? Generally, we are then shown some of the tangential figures kneeling or whatever as they gaze up at Christ hanging there from his precious tree. Or maybe the outside panels show us the patrons of the artist, the affluent persons who paid for the painting, painted into the crucifixion, as it were, and are usually displaying signs of their piety. To be honest about it, these scenes don't usually come off very well. There's something that feels awkward since what in the world are the patron and his wife really going to be doing at the outskirts of Golgotha or wherever, what could the patrons possibly be doing that is going to be appropriate to this scene, in what way are they not going to look ridiculous as sudden, anachronistic voyeurs to the crucifixion of Christ? How is this not absurd?

As I've said, I don't think Joan Mitchell's *Girolata Triptych* is anything other than a landscape when you get right down to it. But it is a pretty darn intriguing

The Grand Valley

landscape for the fact that it also reads as the abstraction of a crucifixion triptych. It's got the central figure in the middle panel and then a few interesting things happening in the middle and then a couple of subsidiary happenings off to the side on the two flanking panels. It's the memory of a crucifixion problem metamorphosing into a landscape.

It is easy to see that Joan Mitchell had become focused on issues of landscape from other paintings she painted in 1964 and from some stuff John Ashbery wrote about her paintings and also from a triptych she painted in 1966–7 called *Chicago*, which is a painting of Chicago that no one in their right mind could ever identify as Chicago but that is also, in some frustratingly compelling way, about as completely Chicago as any painting could ever be.

I should also probably mention that it must have been John Ashbery who first got me wondering about why Joan Mitchell kept staying in France when it made no sense to stay in France. The France mystery. It didn't start with me. Ashbery saw it and helped me to see it. Joan Mitchell, Ashbery says, is really more of an *apatrides* than an expatriate. Apatrides, according to John Ashbery, feel more or less bad about being anywhere and so they stay somewhere without good reasons for doing so precisely because when you are somewhere for no good reason, like in Paris after WWII, you tend to get left alone for the simple sheer reason that no one cares. Ashbery doesn't put it exactly that way, but this is basically what he means. Going on, Ashbery asks a

What is a landscape? What is a crucifixion scene?

very frickin' insightful question about Joan Mitchell's paintings, and thus about all abstract painting that still somehow bears some relation, in however a tangled way, to experiences of viewing or experiencing the actual world. I'm going just to quote what Ashbery says, both what he says and then asks and then tentatively answers, sort of, and I'm doing that because Ashbery was quite capable of putting things into words without my help while also knowing the limits of putting things into words, and in musing through a couple of musings and asking himself a couple of questions, Ashbery gets very damn close to the core question of what painting is full stop, and certainly of what Joan Mitchell's painting is, if it's anything. He wrote:

> The relation of her painting and that of other Abstract-Expressionists to nature has never really been clarified. On the one hand there are painters who threaten you if you dare let their abstract landscapes suggest a landscape. On the other hand there are painters like Joan Mitchell who are indifferent to these deductions when they are not actively encouraging them. Is one of these things better or worse than the other, and ought abstract painting to stay abstract? Things are not clarified by artists' statements that their work depicts a "feeling" about a landscape, because in most cases such feelings closely resemble the sight which gave rise to them. What then is the difference between, say, Joan Mitchell's kind of painting and a very loose kind of landscape painting?

The Grand Valley

It's a question we could very well still ask about the Grand Valley paintings, that suite of paintings, that series of paintings that Joan Mitchell took to painting many years after she had learned something about landscapes and places and what her paintings can do from *Girolata Triptych* and other paintings, and long after that period in the mid-1960s when Joan Mitchell was finally able to produce her giant suite of twenty-one canvases that could, themselves, be described as a "very loose kind of landscape painting."

Ashbery is here raising the rather difficult question of what we really mean by landscape or seascape or cityscape or any of those words when talking about Joan Mitchell's paintings. Is she an abstract painter or not? What do we mean by saying that *Girolata Triptych* is a seascape or, more properly, a landscape by the sea? The only really honest answer to this question is that we just don't know. We really don't have a damn clue what we are talking about when we say that this or that painting by Joan Mitchell is a landscape or a seascape or a nature scene or whatever. She spoke a few times about her paintings being the feeling of what it was like to be in this or that place in this or that time and Ashbery is savvy enough to note that this doesn't seem quite to solve the problem, since, as he puts it, rather devastatingly, "in most cases such feelings closely resemble the sight which gave rise to them." You could maybe try to take another step back then and call the paintings a sort of visual memory. Or the memory of a feeling. Or the sense of the "what it was like" to be, say, in a specific

What is a landscape? What is a crucifixion scene? area of Corsica on a certain kind of day. The "what-it-is" of that place in Corsica at a specific time of year and a particular time of day and a certain mood you might have had when you were there and all this has a texture and a color, or a few different colors, and it has a certain brushstroke even, the color wants to go across the canvas in this way instead of that way. This is basically what Ashbery says in his actually quite astoundingly insightful little essay written in April 1965. He basically says that feeling and memory exist in some relation to the original experiences of nature or cities or whatever and that Joan Mitchell paints the distance—which is greater or larger as the specific case may be—between these feelings and memories and the original experience. Which is a pretty damn revelatory thought, when you get to thinking about it and looking again at the paintings of Joan Mitchell.

This is why, for instance, *Chicago* has a lot more skitchy-sketch sorts of marks on it than *Girolata Triptych* has got. Joan Mitchell's sense of Chicago, of the "what-it's-like" to be in Chicago, was that you've got to go skitchy-sketchy on the canvas and skiddle about on it with the brush and then just hunker down in a few spots of the canvas and let the skiddling build up over and over again into a density. But Joan Mitchell's experience in Girolata was much less skitchy-sketchy. There is some skitching and some sketching, mind you. There's always a bit of skitching and also a fair amount of sketching in any Joan Mitchell painting because life was like that for her, it was skitchy-sketchy. Like how

mornings were jingle-jangle for Bob Dylan. But the interesting thing that happens in *Girolata Triptych* is that there are just some longer fwoops of the brush and the fwoops peter out all along the perimeter of the bolder patches of color, which are patches mostly of a deep black and a very dark green over the black and then some little splizazzles of orange and even a mad zimmer of pink you don't see at first but then becomes a big deal the more you look at the painting.

Of course, I was talking initially about the funniness of *Girolata Triptych*. The funniness of it is that it is just a crucifixion, the essence of a crucifixion. I mean, it's the triptych with the focus, the biggest element of the painting, the major move being the great patch of black-green in the more or less center of the central panel and then the two patrons or thieves or whoever off in their smaller black-green splotches in the side panels. There it is: the essence of a crucifixion without any need to bother with the details. Christ, a blob of green, and then a couple of patronizing green blobs trying to get in on the action just off to the sides. There it is, hundreds of years of European painting summed up all at once.

Not that this is what Joan Mitchell was thinking about. Not consciously. She was thinking about a seaside spot in Corsica. Or not thinking about it. Not thinking about anything exactly. Being that spot, maybe. This was a peculiarly idyllic time for Joan Mitchell, at least on some of the days. She was lounging around the Mediterranean on various boats, spending time in beautiful places with nothing much to do but while away the days

What is a landscape? What is a crucifixion scene?

in the sunshine and talk to friends and have charming lunches. She was in love. Of course, she was in love with Jean-Paul Riopelle, which was, in fact, a problem and ever more so with each passing day. Riopelle was a more important and recognized painter than Mitchell at the time, though that has very much reversed since then. He was possessed of voluminous hair atop his head and a voluminous appetite for pretty much everything, a voluminous love for the many experiences of life and many of the people he encountered in life and also, primarily, himself. He was a large and talented man and he was a baby. That much can be stated clearly. He was in love with Joan Mitchell during these Corsican days, which Joan Mitchell found to be quite exhilarating, and all the aforementioned factors no doubt contributed to an excess of feeling-memory coursing through the body and soul of Joan Mitchell as she lounged away the season of 1964 cruising the Mediterranean.

The painting, then, is a painting of what was left to Joan Mitchell, left in her memory and feelings, of the experience of those magical days. But that's not right either. Because she is there too. Not just the place and the feeling, but the person having the feeling also. Some version of Joan Mitchell is in that spot in Corsica. Girolata. There has to be someone in Girolata for Girolata to be what it needed to be on that specific day, that afternoon, the afternoon she painted the painting. The subjective and the objective get all mussed up with one another. Or were they even disentangle-able in the first place? Probably not. There is someone there, Joan

The Grand Valley

Mitchell, and there is the location and all the vagaries of the moment, the specific breeze in the air, the smell of whatever, the sea I suppose, and the feel on the skin of the air in that place on that day, and the mood and the sense of self that must have been in the being of Joan Mitchell that day, the lingering considerations in her mind, the subtle smell of Jean-Paul Riopelle on her skin, the inchoate thoughts sliding around in the mind and then receding into the background as she enters a certain kind of now-space of the "what it was like" to be right there in that spot of seascape and town on the west coast of Corsica. But even to try to describe it this way feels insufficient in the end, like it's saying both too much and too little, like it has missed something that exists in actually viewing the painting but that resists every attempt at communication.

Anyway, it was these days lounging around and having quasi-experiences in various places of the Mediterranean in the mid-1960s that ultimately prepared Joan Mitchell for the Grand Valley paintings she would make in the early-to-mid-1980s. The seed was planted. The idea that a painting can have an ambiguous and almost-not-even-quite there relationship to something in the world or something in the memory of the world or something in the memory of what might have been an experience that is now a hazy memory. In the Grand Valley paintings, Joan Mitchell realized that she had almost total freedom to trust what would come out of her when she stood in front of a canvas with all her brushes and her music playing and her mature sense

What is a landscape? What is a crucifixion scene?

of what makes an experience an experience. By the time of the Grand Valley paintings, she wouldn't even need a memory anymore and she wouldn't need the not-having a memory even to be her own not-having a memory. It could be anyone's memory or almost-memory or not-really-quite memory or made-up memory. It didn't matter. Her canvas and her paint and her dabbing and scritchy-scratching could conjure up anything in that hazy world where imagination creates feeling-environments for what a possible experience is like. But we are getting ahead of ourselves here. In the mid-1960s, Joan Mitchell wasn't yet ready for the task of the Grand Valley paintings. She was preparing, though she knew it not. She was preparing herself without knowing that she was preparing herself and she was waiting for other things to happen, which, as is always the case, they were about to do. Or perhaps we could say that she was being prepared.

6. A return to Gertrude Stein and Alice B. Toklas and some reflections on *The Making of Americans*, Gertrude Stein's most brilliant and unaccountable work. And are there two Gertrude Steins?

ONE OF THE MORE arresting statements that Gertrude Stein makes in *The Autobiography of Alice B. Toklas*, ostensibly a book about Alice B. Toklas that actually tells us nothing about Alice B. Toklas and nothing about anyone else either, is about another one of Stein's books. The other book is much, much longer than *The Autobiography of Alice B. Toklas* and is so long and repetitive and difficult to read that Janet Malcolm, in her very interesting and disturbing and sometimes very funny book *Two Lives*, which is a biography of both Gertrude Stein and Alice B. Toklas and which is also therefore a book almost as tricky as Gertrude Stein's *The Autobiography of Alice B. Toklas*, tricky because Janet Malcolm knows very well that you can't very well write a biography of two people in one book, and, moreover, uncovers tons of strange material about the behavior of Gertrude Stein and Alice B. Toklas mostly just to convince us,

A return to Gertrude Stein and Alice B. Toklas

finally, that we know even less and understand even less than we thought we knew and understood about these two famous women who were pretty elusive in the first place but now are even more so, and in that strange and fascinating and obscuring biography of hers, Janet Malcolm mentions that no one has actually read all of Gertrude Stein's biggest and most difficult book, this being the book Gertrude Stein called *The Making of Americans*, which comes in at around one thousand pages and weighs in at about two and a half pounds depending on your edition of the book, and which is indeed almost impossible to read, I have found, for more than a half an hour or so at a time without drifting off into a kind of stupor, not actually an unpleasant sort of stupor, it should be mentioned, but definitely an altered state of semi-consciousness in which I was never sure exactly when I stopped understanding or being conscious of what I was reading and when I entered into a state where the words were just happening on the page and had fallen into a quite profound state of what can only be described with the word *stupor*. That book, *The Making of Americans*, is a stuporific book. It stuporifies you, is the point. I know, by the way, that I am also doing that right now. I'm not stupid. You are being stuporified. I know that. I'm aware. We both snap into awareness at this moment right now. Me, the writing, and you, the reading.

But in *The Autobiography of Alice B. Toklas*, Gertrude Stein writes at one point, talking about herself instead of talking about Alice B. Toklas (but what else

is new?), that *The Making of the Americans* was meant to be the history of a family but that by the time she came to Paris *The Making of Americans* "was getting to be a history of all human beings, all who ever were or are or could be living." This, like many of the things that Gertrude Stein wrote and said until she died horribly of a nasty stomach cancer, is completely absurd. It is not possible to write a history of all human beings. But Gertrude Stein does not stop there. She suggests not just that *The Making of Americans* is about all human beings who ever lived, but all human beings who ever could in the future exist on earth, or any other place presumably. It's a book, then, that takes in the entirety of actual living and dead human beings, and that also takes in all the human beings who could potentially live and die. It encompasses actuality and possibility, all of it, in toto. That it is a two-and-half-pound book seems, reflecting on this aspiration, actually quite an accomplishment of brevity.

But of course it is not the length of the book that makes it a history of all human beings, actual and possible. It is something else. Gertrude Stein means something else by this claim, surely. We know that she means something else because the book gives up on speaking about anyone in particular early on anyway. It starts out as a story of a specific family, sort of, and then ceases being that very quickly. That's not entirely true. In *The Making of Americans*, Gertrude Stein circles back around to the specific family she's talking about and to some of the relationships in that family and throughout

A return to Gertrude Stein and Alice B. Toklas

the book there is a constant returning to the specific lives of people, her people, her family. Sort of. I don't know, I can barely remember any of the details, that's for sure. I remember something about the Dehnings in the country being a simple and pleasant people. I believe that line is repeated many times, as many other lines are repeated many times in the book, and many ideas are repeated and circled back to and swirled around many, many times. But then there are vast chunks of *The Making of Americans* in which Gertrude Stein has departed from even a vague reference to these specific people—the Dehnings or anyone else—and she allows page after page to flow from her pen that are hard to describe as anything but the turning over and around of certain sentences just for the interest in the sentence itself, if we can put it that way. And the sentences get turned over and worked over and in all the turning and working they start to lose any sense and become completely absurd and lose all possible contact with anything specific, and then get turned over and worked over even more and then sometimes those sentences return to a kind of meaning or take on a different sort of resonance than they had before or just fall apart completely, sometimes, never to be redeemed at all, or, in some cases, the worked-over sentences find their way back into the thread of a story that, while not like any normal sort of novelistic story, returns us to the thoughts and feelings and actions of a people called the Dehnings or of other people or of the world of day-to-day experience more like the sort of day-to-day experience that anyone

reading the book, *The Making of Americans*, could identify as the sorts of thoughts and emotions and events that make up the day-to-day.

It is in those parts of the story, the telling of things that Gertrude Stein undertook in *The Making of Americans*, it is when the writing begins to detach itself from the particular mooring of the family, the Dehnings, and begins to circulate around on its own axis, it is at those points that Gertrude Stein does seem, possibly, to be telling the story not of this or that particular American or even this or that particular human being but something more like the story of "human being" as such.

There is a question here of who is writing. Who is writing at those moments in *The Making of Americans* when Gertrude Stein has really got herself going and the sentences are repeating and spooling around one another and becoming strange to read and then taking on a weird lyrical quality where the words just sound like something that has nothing to do with what they actually mean, and then the sounds of the words reveal variations in meaning or the sentences get lost in the absurdity of how the words sound and in the absurdity of the events and actions and feelings that the words are supposed to tell us about and the utterly meaningless random shit that is the core of any doing or saying and even as all of this circulates in the sentences on the page, as those sentences are threatening to collapse into absolute and complete gobbledygook there are little poignant reminders that this, this spiraling cavalcade of words and actions and thoughts and feelings, this

A return to Gertrude Stein and Alice B. Toklas

complete mess of language and incessant repetition and slow-building variations on one obsessive thought or image after another, this whole cavalcade of language pouring out over itself is, one comes to realize, also, exactly what it is like to be a person. It is absolute realism. Total surface nonsense as absolute realism. Language tripping over itself in complete stupidity as the expression of what is deepest and most profound or what it is like really and truly to be a person, any sort of person. And so in a funny way Gertrude Stein was right in what she said about *The Making of Americans* in *The Autobiography of Alice B. Toklas*. It is the telling of "human being" as such.

And it is just not clear exactly who is writing when Gertrude Stein loses herself in the language at certain points within *The Making of Americans*. It is almost as if the language itself is writing, as someone like Roland Barthes or other people like that might put it. Like it is language writing itself and Gertrude Stein is just along for the ride. But that's actually not quite right either, with all due respect to the French poets and theorists and the various post-Heideggerian rhapsodists on the subject-less power of language. I mean, these people are right and they are not right. Language itself is the boss. Sure, this must be true. Language is bigger than any of the specific users of it. Language sets the rules. Language is the one that makes us, we don't make it, except in the tiniest ways by which it, language, gets warped and fiddled and sculpted at the edges by all the people actually using it, by all those actually instantiating the

thing, language, that somehow exists beyond all of its specific practitioners. But still it is not quite the case exactly that Gertrude Stein disappears in those remarkable passages and that she is replaced by language itself. It is not language as such that is languaging when language gets most wild in the wild ride of *The Making of Americans*. I say that because it is still Gertrude Stein. She hasn't gone away completely. There is never just language languaging, even at the farthest edges of some Symbolist poem by Mallarmé or whoever, one of those French chaps, there is always still someone, some kind of particularity there, and yet at the same time that particularity is maybe just at the cusp of dissolving into that thing that never actually exists, language itself.

Anyway, she is still there, through every word of *The Making of Americans* she is still there, Gertrude Stein. I can feel her in there and I think that you can too. Two pounds into the book or however far you get—and most people, even the Gertrude Stein scholars, as Janet Malcolm reminds us, even the die-hard Gertrude Stein people are often lying when they say they've read each and every word of *The Making of Americans*, but still— however many pounds or ounces you manage of that impossible book you can still feel her, the hulk and bulk, the specific stubborn heaviness of that person Gertrude Stein, it can be felt. Not language languaging but Gertrude Stein languaging. But also not the same Gertrude Stein who started the thing. There's another Gertrude Stein who begins to emerge as the sentences really start to get going and as the language really starts to unspool.

A return to Gertrude Stein and Alice B. Toklas

Can we put it that way? Are there really two Gertrude Steins? No. Of course not. And yet, yes, yes there are. In some way hard to explain there are two Gertrude Steins. One is the person who wrote *The Making of Americans* and who we learn a certain amount about, though not very much, actually, in books like *The Autobiography of Alice B. Toklas* or in clever double anti-biographies like Janet Malcolm's *Two Lives*. This Gertrude Stein has a specific life story, who did this and that on this and that day. And then there is another Gertrude Stein who starts to peek out from the shadows, the murk, the strange space of language as it begins to language itself in the deepest murkiest sections of *The Making of Americans*. There is another person there. Another version of being a self. There is a self that is a kind of non-self. Can we put it that way? Or a self that is a kind of all-self. Could we put it that way too? This non-self-all-self also still has a Gertrude Steinness to her. She is selfhood verging into the non-self-all-self but with the distinct flavor, the still lingering mood and particularity that is what we might call Gertrude Steinness. She's still that. She is still the GertrudeSteinCreature that went into the project of writing *The Making of Americans*. But she has cast something off as well. She's become another sort of self, one much harder, one much trickier to get one's hands on, so to speak. The point of *The Making of Americans* is to drive language so hard into itself that this other self can begin to emerge, and this other self is going to be able, in some murky way, to speak for all selves, for all human being.

7. The critic and personality Dave Hickey enters the picture. He brings with him the idea, which he repudiates, of there being two Joan Mitchells, Big Joan and Little Joan. The existence and the nonexistence of Big Joan and Little Joan.

THE CRITIC AND WRITER and impresario and personality and gallerist and showman and shaman and whatever else you want to call him named Dave Hickey once wrote a short piece about Joan Mitchell. This short piece is important for us because Dave Hickey, in this short piece, really digs into the proposal, proposed by Joan Mitchell herself, that there's a Big Joan and a Little Joan. Joan Mitchell, in the film we've already mentioned, *Joan Mitchell: Portrait of an Abstract Painter*, and in other places and to plenty of other people, talked about the fact that she, Joan Mitchell, was actually not one person, Joan Mitchell, but that she was two persons, Big Joan and Little Joan. This was her own idea. Or, to put it more precisely, the Two Joans was actually the idea of the person who was her therapist for many years and then, through the process of talking with her therapist

The critic and personality Dave Hickey enters the picture for many, many years this idea that there is a Big Joan and a Little Joan became Joan Mitchell's idea of herself, that's to say, herself as a double-self, and that idea became so comfortable for her that she was perfectly happy to tell other people about it too.

The basic way that Joan Mitchell explained the difference between Big Joan and Little Joan was to say that Big Joan was the tough Joan Mitchell, the hard drinking and testicle-grabbing, the violent and abrasive Joan Mitchell who went out into the hard, cruel world and dealt with the people of the hard, cruel world as best she was able and with all the toughness required, especially of a woman who was going to hang out at the Cedar Tavern with the macho painter types of the era and deal with the condescension and the misunderstanding and the sexism and the stupidity and the just basic lousy and disappointing nature of the world in general. The world is, most of the time, disappointing and shitty. You may have noticed this.

Joan Mitchell certainly noticed this troubling and nagging little detail about the world. Every alcoholic who has ever lived, it might be mentioned, has noticed this troubling detail about the world, noticed it in spades, and has noticed, moreover, that alcohol has a satisfying tendency to make the shittiness of the world temporarily less shitty or, barring that, to make the imbiber of said alcohol much less vulnerable to the feelings of the shittiness and the overall lousy disappointing and simultaneously overwhelming, emotionally overwhelming character of the world as just the sort of drab

and mean-spirited place that it happens to be, much of the time, far, far too much of the time. So, Big Joan was the Joan that Joan Mitchell sent out into that world, the shitty world. Big Joan was going to deal with the shit as best she could. Big Joan was going to meet shit with shit, drink quite a lot of whisky, and was potentially going to punch you in the face and maybe also bite you.

And then there's Little Joan. Little Joan is the one who paints, basically. Little Joan is the one that Big Joan protects. Little Joan is tender where Big Joan is hard. Little Joan is vulnerable to all the slings and arrows of outrageous fortune. Little Joan feels everything and is susceptible to everything. Little Joan is open to the world. Little Joan listens to the Mozart or Billie Holiday or the whatever Joan Mitchell happened to be playing in her studio that day, and Little Joan lets every aspect of the music and the feeling and the sense of the day and the canvas and the smells and sounds of that particular day flow through her in whatever way it needs to flow through her, and Little Joan is the fragile and woundable Joan through whom the painting happens. Little Joan has to be open because it is only in this radical and dangerous opening that the painting can happen. Basically. That's the basic set up between Big Joan and Little Joan.

But Dave Hickey, in the essay he wrote about Joan Mitchell called "Epigrammata," Dave Hickey takes a certain amount of umbrage at this idea of Big Joan and Little Joan. We'll decide if Dave Hickey's umbrage is justified or not in a minute, but at least it should be said

The critic and personality Dave Hickey enters the picture that Dave Hickey takes umbrage out of a significant admiration and respect and love for the painting of Joan Mitchell. There is no question about that. She's the best, he says, the best of her generation. Okay, so she's the best. And the whole problem that Dave Hickey brings up, the whole justification for his state of umbrage, which increases in its umbrageousness throughout the essay, is his objection to the Big Joan and Little Joan interpretation of who Joan Mitchell was as a person and what she was doing as a painter. Joan Mitchell was too great a painter, Dave Hickey says, for us to accept this Big Joan / Little Joan crap.

The real crux of it, the source of Dave Hickey's great state of umbrage, is basically and fundamentally that he likes Big Joan and he doesn't have much truck with Little Joan. He wants Big Joan to be the one making the paintings, not Little Joan. What's this bullshit about Little Joan behind the scenes, poor little Little Joan who is all meek and wounded and vulnerable, what's all that crap, Dave Hickey is basically asking, since the canvases themselves have all the brashness and the anger and the energy and the kick you in the eye sort of aggressiveness that you would much more associate with Big Joan than with Little Joan. Life, Dave Hickey seems to be saying, is rough and brash and sensual and senseless and all of that together and more, and the wild ride of it, just of being alive and falling in love and then also hating someone and wanting to punch their face out, fighting and fucking and warring and surrendering, all of this stuff is the real truth of life and that this

The Grand Valley

boundless and pitiless energy is precisely what Joan Mitchell captured on her canvases, and because of this, argues Dave Hickey, to boil his argument down, because this is what life is about and because Joan Mitchell lived her life in exactly that way, fucking hard and fighting hard, drinking smoking swearing, dealing out violence and being dealt violence, because of this it is Big Joan all the way through. Big Joan is the one who painted all those extraordinary paintings, is what Dave Hickey is trying to tell us, and anyone who says different, even if Joan Mitchell herself is the one saying it, all the garbage about Little Joan is just that, garbage.

That's what Dave Hickey says and that's why he's in a state of great umbrage on the matter of Joan Mitchell and especially on the matter of Big Joan and Little Joan. He's right, of course, Dave Hickey is, that there is something funny going on with the whole Big Joan / Little Joan trick. I mean, we've already talked about the way that every Joan Mitchell painting is in some important way a bruise. And the bruise is itself injurious. Seeing the bruise is intense and potentially upsetting. People who look at Joan Mitchell paintings and claim to see lovely pretty things are, as we've already mentioned, deluding themselves and also probably not even looking at the paintings in the first place. Even a painting like *Girolata Triptych*, which is a funny riff on the tradition of the crucifixion and is also a very particular kind of land-seascape is, along with being both of those things, also a pretty nasty bit of dark green and black spat out onto the canvas along with a few other colors scritched

The critic and personality Dave Hickey enters the picture

and scratched around the more upsetting blotches of wretched dark green. There is something very dark in this painting. There is some kind of root hurt, root anger coming through in this painting. You could see, then, why Dave Hickey might want to object that, if Little Joan is the painter, if Little Joan is the gentle and meek and quiet one who paints the pretty pictures, then why does it seem to be the case that Big Joan painted this picture? Why does this picture seem as difficult and confrontational and angry and alive and expressive and as willing to be injurious and also to be a bruise, to be bruised, why is this picture, if it was painted by Little Joan, why is this picture the very embodiment of Big Joan?

It's a fair question.

8. Talking about Dave Hickey forces us to talk about Carl Gustav Jung, the Swiss academic and also, it turns out, strange mystic or prophet or something. This Swiss person took a train ride to hell and came back with some interesting news.

PROBABLY WE HAVE to go to Switzerland in an attempt to say more about Big Joan and Little Joan and the dilemma Dave Hickey has posed for us. And I'll tell you a story.

On the night of 12 December 1913, a certain Swiss named Carl Gustav Jung was on a train ride to Schaffhausen, a little Swiss town near the border with Germany. He was going to visit his mother-in-law. The train ride took him about an hour. During that hour something happened. Carl Gustav Jung did not see the pretty scenery of the Swiss countryside. Instead, he had a vision of floods, massive floods that covered up all the land. A couple of weeks later, he saw a sea of blood over all the lands of the north. He thought that perhaps he was going crazy, a not unreasonable thought given the circumstances. Perhaps he was right. Carl Gustav Jung

may, indeed, have gone completely mad right there and then on the train ride to visit his mother-in-law. He might have been stark raving mad until his final days in Küsnacht in 1961. What if Jung was just completely nuts the whole time?

Anyway, the visions continued. The following year, Carl Gustav Jung began to have dreams in which the floods of his earlier visions turned to ice. He saw ice coming down from outer space, ice covering everything and the entire land became frozen. Naturally, being Swiss even in his dreams, Carl Gustav Jung took some leaves from the frozen trees and pressed them into a delicious ice wine. He dispensed this ice wine to the waiting throngs. He had something sophisticated to give to the people, even in his dreams. In truth, Carl Gustav saw himself as a prophet and always knew that he was a prophet and, moreover, had the interesting Swiss guile to figure out that if you are a prophet in the twentieth century you've got to hide yourself in another form. But he didn't, Carl Gustav Jung didn't immediately accept the idea of himself as prophet. It took him some time to settle into the idea, the reality of his prophetic being. First, he had tons of crazy visions and had to sort out these visions.

Carl Gustav Jung later realized that this period of visions came upon him, as it did to Dante, in the middle period of his life. He had been a successful doctor and an eminent personage of his time. He was wrapped up with Freud and with all the excitement around the "discovery of the unconscious." But that relationship

was ending. The famous break between Carl Gustav Jung and Freud was in the very process of happening just as Carl Gustav Jung was having his wild visions on the train ride to go see his mother-in-law. Just as his life seemed to be one thing, it was transforming unaccountably into something else. And so the visions. And so the descent. So the falling.

What happened to Carl Gustav Jung, at least according to his own account of it, an account that can be found, mostly, in the inordinately strange and almost impenetrable book that he wrote and drew and painted and which later came to be known as *The Red Book*, which ought to be placed on any bookshelf just beside Gertrude Stein's *The Making of Americans*, and which was only published, only released to the public many years after his death for the very reason that Carl Gustav Jung, the eminent physician and scientist and person of his time, this public figure, Carl Gustav Jung, not wanting to alarm his patients and his public, not wanting to cause a scandal, withheld this volume of his writings for many years knowing full well that the having of watery visions and the visions of rivers of blood and of vast sheets of ice coming down from space, that all of this is, shall we say, a bit on the eccentric side at the very least. It might not have gone down, this *Red Book* might not have gone down very well at all, amongst those already a little suspicious of all the delving into the unconscious and the talk of hidden depths and the discussion of ancient symbols and mythology and the creeping right into the zone of potential mumbo jumbo

that had quite a few people worked up into a mode of suspicion about all the things going on around Carl Gustav Jung and his circle.

So, *The Red Book* remained hidden for a long time. Only relatively recently was it released to the general public. And in this book, in this red book, Carl Gustav Jung reveals that in this time around the period of the train ride to visit his mother-in-law in a charming Swiss town, at about this time it so happened that Carl Gustav Jung realized that his soul had long ago left him and so he was plunged into hell, we might as well say it, and he wandered around in hell for a while and then he came out again and his soul returned because he, Carl Gustav Jung, had acquitted himself pretty well in hell, he'd done a good job in hell, I guess we could say, and so his soul came back to him and he, that is Carl Gustav Jung and his soul, came to the agreement that he could, after this brief period in hell, go on being a successful and somewhat stodgy Swiss physician type for the rest of his life and that would be basically okay with his soul, with hell, and with God. That's the story in a nutshell. There are a few dragons and witches and prophets and burning lakes of fire and such betwixt, but that is basically the story.

9. More is learned about the travels of Carl Gustav Jung into hell. Hell is a place that must be encountered. Down there in hell, you learn to be the person you had always been in the first place. It's a paradox. But a nice one.

SO WE HAVE TO take in the information that Carl Gustav Jung, who had all the visions and dreams, the Carl Gustav Jung who wrote *The Red Book* and who made all of the drawings and the paintings that make up *The Red Book*, this Swiss, this Carl Gustav Jung, this fellow with his wool suits that always seem to me, amusingly, these suits that always seem to be just about one size too large, this Carl Gustav Jung was a man who traveled through the depths of hell and who came back out again. He went to hell, and then he came out and went back to Switzerland.

The Red Book is simply an account of a journey, a journey that happened within the mind or some might say the soul of a Swiss named Carl Gustav Jung. This journey was the journey from sanity into insanity. There is, here, a simple, thumbnail difference between

More is learned about the travels of Carl Gustav Jung

the life and work of Sigmund Freud and the life and work of Carl Gustav Jung, by the way. The thumbnail difference is just this. Freud worked his whole life in order not to get uncorked, to help others re-cork themselves and to figure out ways not to get uncorked in the first place. Jung continually sought to get uncorked and while he did sometimes help others in their re-corking, the people he was most interested in, the experiences he sought the most were amongst those who had let the uncorking go as far as possible, let it go beyond the edge and out the other side again.

It is precisely in getting uncorked, or so the proposition goes, in losing oneself completely, in going over to the other side, that one can find oneself again, or, better said, find oneself really and truly for the first time. That was Carl Gustav Jung's obsession and what he always preached, if he can be said to have preached, and it is the primary story which he put into the images and visions of *The Red Book*, a book that speaks on the level of myth and of symbols and of the archaic but which is always saying more or less the same thing, which is that hell is real and you really ought to go there. You should get uncorked, descend into hell, and then emerge again, and in doing so you have a very good chance of knowing who you actually are, not who you thought you were, which was necessarily an illusion, but who you actually are. What Carl Gustav Jung found in hell, what he found in the dark place, what he found amongst the deepest shadows, the truly scary place of the darkest and most obscure shit that we all have within ourselves,

that place, the place that everyone pretends, most of the time, does not exist at all but most assuredly does exist, it exists within, and one can find those shadows, those most terrifying corners and empty hallways of the soul, down in the depths of those most horrible places where Carl Gustav Jung dared to go, and in this sense he was quite a courageous Swiss indeed, down there in the pit, the pit that is within each and every one of us, there in the fiery pit is where Carl Gustav Jung discovered, somewhat surprisingly, that he was, and should be, a ridiculous Swiss doctor wearing one-size-too-large wool suits and a person playing the game of being the professional and the academic and the eminent man of his time.

The great and hellish journey, the visions of flood and fire and then of ice, the journey to face witches and dragons, all of this is undertaken by Carl Gustav Jung, all of this grand and incredible narrative, all of which is related in the portentous and sweeping and more or less medieval tale of epic grandeur that is *The Red Book*, and at the end of it, the final lesson that we get from all of this is that Carl Gustav Jung gets to be exactly what he'd already been, he gets to be a somewhat ridiculous provincial doctor wearing ill-fitting suits. There is some footage of Carl Gustav Jung in his elder days, comfortable in his position as the eminent man, speaking on this or that topic. But there are moments when a smile can be seen flittering across the face of this Carl Gustav Jung. One can see that he is standing just a bit outside himself. He is playing the role. He is in himself. But he

More is learned about the travels of Carl Gustav Jung

is also outside himself. He is in and out. He is, just for a second or two, observing himself perhaps from one of those strange places that he tells us about in *The Red Book*. And what he sees is a silly man completely bound and determined by the lifeworld of his time, by the petty circumstances of being a Swiss doctor and academic. And he smiles because he knows it is absurd. He knows it is absurd, but he has completely embraced it nonetheless. He has become that person completely and totally even though he is fully aware that he is a kind of joke even to himself. And that, he seems to be saying, is what it means to be individuated. Really and truly it is nothing more than that. To play it out. To play out the joke that you are. To be bound completely by space and time and limitations of every sort, by culture and era and history and circumstance, to be held into place by childhood moments that you could never have chosen or controlled, to be buffeted by thoughts and feelings that were generated and that shaped your soul before you ever had the chance even to realize what was happening. To be all of that. To be all of the pettiness even as one knows that it is possible to step outside of that pathetic individuation, to know that one can touch upon the great sweep of Being, a consciousness that is, in fact, beyond the consciousness of oneself as the individuated self. To have stepped into the fires of hell and burned it all away. To have melted into the great humming pulsing cosmic throb of Being like an ancient maenad or something, to have merged into the crazy swirl of absolute being and to have emerged from that swirl

and gone back to Switzerland. Why would anyone do it, why would anyone return to the doctorly practice in Switzerland after having undertaken the extraordinary adventures of *The Red Book*? Why would anyone choose the mundane when one had glimpsed, so to speak, the actual face of God? Why does Jung come back to us?

Because he has to, of course. Because that is what he learned in hell. What you learn in hell, what you learn in the shadows and from the shadows, what you are supposed finally to figure out is that you do, actually, have to be the fucked-up person that you don't really want to be, that in some deep sense you hate. You must embrace, fully and completely, being the pathetic and limited individual that you actually are. That's it. That's the thing one learns in hell. Simple. But very hard to carry out. Very hard to live through.

10. Back to Joan Mitchell and the intractable France problem. And not just France, but a little town in France in particular. You can't confront Joan Mitchell without also confronting Vétheuil, which also means confronting Monet, which also means confronting sunflowers, which also means confronting death.

PERHAPS ONE OF the reasons that Joan Mitchell went to France and lived in France and, from the early 1960s until the day she died in 1992, was more connected to France than to any other place, perhaps the reason she lived in Paris and had a big studio in Paris and then also, later, had a place, a quite nice place in Vétheuil, the nice little town on the bend of the Seine river where she would eventually paint her twenty-one canvas suite of paintings known as the Grand Valley paintings, and which is not far from Giverny—Giverny being, of course, the famous place where Monet had a home and where he sat and looked at the water lilies and painted

The Grand Valley

all kinds of paintings of water lilies, was more a matter of fate than anything else. Because Monet lived in Vétheuil for a short time as well, before he finally moved to Giverny, not too far away, he more or less lived and painted in Giverny for the rest of his life. Monet was in Vétheuil for a couple of years from the summer of 1878 until sometime in 1881, I think, and it is in Vétheuil that Monet's beloved first wife Camille died of uterine cancer. Monet had a sort of breakdown in Vétheuil after the death of Camille, and perhaps you could say that he, too, died a little bit in Vétheuil, and had a crisis of existence and of going on with life, did not know how to go on, and was mentally, emotionally, in all those sorts of ways, a complete wreck, so the story goes, for many months, probably a year or so, perhaps more, after the death of Camille. And then he started painting again and probably at that point truly became the painter that we think of as Monet, the period after the death of Camille and just before he moved from Vétheuil to the place in Giverny that will probably always be associated with Monet and probably no one else.

It was at Vétheuil, after all, that Monet painted *Bouquet of Sunflowers*, which, for all the cliches about sunflowers, for all the tiresome sunflower fetishism that was created by this painting and also by Van Gogh's love of and emulation for this painting, a love that led to Van Gogh's own work on sunflowers, which has itself become such a cliché of popular-must-love paintings that one hesitates to go anywhere near a painted sunflower at this point, after a century and more of people

Back to Joan Mitchell and the intractable France problem

fawning mawkishly over paintings of sunflowers in a vase, after all of this embarrassing mawkishness around sunflowers one still must concede that, in fact, the slavish hordes, the great mass of unwashed museum-goers flocking, or perhaps better said, being herded into sunflower painting exhibits all over the world, this untutored herd is, in fact, completely correct. Sunflower paintings are, perhaps, the best paintings. Up there in the top echelons, at least.

When Monet painted his vase of sunflowers he blew something wide open. His semi-deconstruction of the pictorial plane, which later came to be called Impressionism, his dabbing and daubing and poking smears of color at the canvas in only half-hearted attempts at holding the canvas together, his willingness to let the visual experience fall apart, or just almost fall apart right there on the canvas, his willingness to use incorrect colors and his willingness to let everything get all fuzzy there on the canvas, his bravery, born, perhaps, of not really completely giving a shit about anything in his grief, his collapse right there on the canvas, his indifference as to whether the little table with its red patterned tablecloth ever bothers to differentiate itself properly from the wall (it does not), all of this allows something quite remarkable to happen with the sunflowers themselves.

What Monet managed to do, without perhaps ever realizing it consciously, was to paint a picture of sunflowers in which the sunflowers are both completely alive and also dying just right there on the canvas, alive and reaching up triumphantly at least in the couple of

sunflowers at the top there but also, at the same time, dying and withdrawing and moving away from us, moving up and out and into the light which the sunflowers both absorb and project and which makes these sunflowers so greedily and wonderfully alive and still, at the same time, dying and, really, already basically dead, already passed away, already in the process of becoming the nothing that these sunflowers always already were in the first place. That's what Monet painted. He painted the whole process of something coming to be and then passing away on one static canvas, which is something that you technically shouldn't be able to do because a canvas, a painted picture, doesn't have time in that sort of way, isn't supposed to be able to carry time like that, since painting doesn't change or move or have any obvious dynamism in it at all. Except that it does. Monet discovered that a painting can be the showing of something beautiful passing away in its actual passing away as it actually passes away. There's the painting. The sunflowers are there and they greedily shine and yellowize the scene as sunflowers like to do and then, already, within that very same picture, they are also dying and fading away and passing into the nothing from which they sprang.

You can't call it a *memento mori* like all the famous paintings from the Dutch Golden Age, you can't quite put it in that category because there is no recourse to symbolism here, as the Dutch mostly play it, there is no thing here in Monet's painting that represents death or that comes in to remind us of death, the insect or the

Back to Joan Mitchell and the intractable France problem

particular symbol that might be discovered within the still life that is supposed to be decoded by the viewer who then gets the point that even here, even in this scene of luscious planty vibrancy, even here, *et in arcadia*, lurks the symbol of death, but no, that's not how Monet does it, and that's why the picture is so rightfully appreciated even by those who only look because they are told to look. Everyone, even people who have no idea what they are looking at, basically realizes that this painting is beautiful because it itself, the picture itself is completely alive and also is death. It is a living death picture, which is a very difficult thing to make, to make a thing like that, a picture that is alive in every way and is also dying, and this gets us to the heart of what Impressionism was really about, what it was really trying to push toward, and this is also what Van Gogh understood about Impressionism in general and especially about this picture by Monet, since Van Gogh himself spent some real time looking at Monet's picture and then produced his own sunflowers, in emulation and deep respect for the incredible thing that Monet had done and in his own desire to make a living death picture, which is exactly what Van Gogh was able to accomplish in his own way with his heavier lines and his heavy strokes and his heavy being, this being-heavy that Van Gogh put into his particular versions of what Monet had already shown him was possible and which, in his hard-won heaviness, Van Gogh pushed as far as he could push, having seen with the help of Monet that it is precisely the sunflower, this plant of vibrancy and

life and of striving, this hopeful kind of plant-thing, is also the perfect place for there also to be death, not that the sunflower is a symbol of death, how could it be, but that the sunflower is, in fact, the perfect vehicle by which we can see that death is real, because it is there as the real being of the sunflower, which is also such a glowing blast of yellow life.

To show that thing, that life-filled, uber-yellow thing as death is to have made a triumph on the canvas, is what Monet did and what Van Gogh followed him in doing and what Joan Mitchell herself later did in her own very different sunflower paintings. Since this is what Joan Mitchell wanted to learn how to do, it pulled her inexorably, probably inevitably, toward the town of Vétheuil, where Monet learned how to die, and where he was shown the actual reality of death in his beloved Camille, and where Monet showed that painting can also show that and, more mysteriously, more astoundingly, that a painting can show this life-death, can reveal it by somehow actually just being it, not even portraying death so much as actually taking it on, becoming life-death.

Indeed, there are many other complex reasons I am sure as to why Joan Mitchell moved to Vétheuil, some of those having to do with real estate markets and the availability of homes and the circumstances of the day and all the circumstances that allow someone to acquire a home. But part of the reason has to do, surely, with Vétheuil itself. Even if Joan Mitchell was not fully and consciously aware of this fact, not planning it out and

Back to Joan Mitchell and the intractable France problem

setting things in motion with a conscious plan, even if Joan Mitchell, in fact, simply allowed things to happen as they would happen, it is an extremely interesting coincidence, if we can call it that, it is extremely intriguing that Joan Mitchell ended up buying a house in the town in which Claude Monet died to the world, if we can put it that way, the place in which Claude Monet experienced the greatest crisis and trauma of his life and then emerged from this crisis as the very painter who would later astonish the world, not to make too much of a melodrama of the affair, but who would go on from the crisis of Vétheuil and the death of Camille and begin a style of painting and a way of putting paint onto the canvas that would change painting forever.

Who knows exactly how Joan Mitchell thought about it. She always appreciated the Impressionists and she was always interested, most especially, in Monet. But maybe it was not up to her, exactly. Maybe the question of Joan Mitchell in Vétheuil is more about what a place wants and less about what the people who end up in the place want. Do places, do locations in the world have their own essence, their own reality, even their own agendas, their own plans and will and needs? But what may very well have happened was that Vétheuil itself got hold of Joan Mitchell, that Joan Mitchell was drawn to Vétheuil for the very reason Vétheuil was drawn to Joan Mitchell.

Places like Vétheuil have stickiness, is the point. And people like Joan Mitchell are already predisposed to be in places like Vétheuil. She had already gone to

The Grand Valley

Paris at the wrong time. Why did she do that? You could say it was love. You could say it was that man Jean-Paul Riopelle, the Bugatti driver and painter of extremely thick paintings from French Canada who was always in Paris too, and who kept luring Joan Mitchell to Paris so that they could fight and fuck all over the city. This was a factor. But not the determining factor. Jean-Paul Riopelle, with his large head of hair, was not the determining factor no matter how fabulously his shock of hair was performing on any particular day. Joan Mitchell was already predisposed toward being lured to Paris, and so it just happened that she was kept there by the roustabout and painter Jean-Paul Riopelle. She was practically begging the world to send her someone like that and to go off to Paris and that's just what happened.

But it wasn't Paris that was calling to her, in the end. The perversity of going to Paris in the time that she went to Paris was only the beginning of the real perversity. Paris was the first part in her journey. To go to Paris already was to look backward, and when a person was painting abstract canvases in the '50s and '60s, the very last thing that you were supposed to do was to look backward, to think about the glimmerings of light and shadow and the mix of memory and experience and forgetting and wanting-to-draw-near and failing-to-draw-near that exists on so many of the canvases of the French painters who made all those paintings that play in the no-space between abstraction and some kind of hard-to-define representation. The representation of those parts of experience that are, in themselves,

Back to Joan Mitchell and the intractable France problem

diaphanous that verge upon the gossamer. Why drag painting back to that? Why drag painting back to all that French stuff when we've finally put it to rest, when we've finally liberated the pictorial space of the painting from all of that?

That was a question Joan Mitchell must have faced, at least in her own mind, and a question that she answered, insofar as such a question can ever be answered, by allowing herself to be drawn to Paris by the well-nigh mythical, mythological figure of Jean-Paul Riopelle. Jean-Paul Riopelle, it must be said, even though it sounds insane and can't really be true, but it must be said that Jean-Paul Riopelle was sent by someone or something, some force, to lure Joan Mitchell to Paris and then from Paris to the even more retrogressive and in addition abysmal town of Vétheuil, which is not that far from Paris in terms of kilometers, only about sixty or so kilometers from Paris as the crow flies but is also hundreds and thousands of kilometers from Paris, and hundreds of years, thousands of years as well. Jean-Paul Riopelle was a fantastically coiffed beast from the ancient world of monsters, a true monster, a seductive monster dredged up from a forest glade somewhere, from the murk of one of the ancient shady places of the inner forests of Europe, and sent out to fetch Joan Mitchell from America and bring her to this other place, bring her to this dark and moldering location rotting away at the outskirts of Paris.

Okay, actually, he was from Montreal. I concede that he was from Montreal. But even that is perfect if

you think about it. He is an intermediary figure. Born in the place that is France in the Americas, if you will, he was the perfect person to guide Joan Mitchell from one world into another. His life overlapped the Atlantic, you could say. He was thus the figure planted by the old gods into the new world, looking for potential candidates, looking for victims you could even say, looking for persons, artists just like Joan Mitchell, those sorts of souls that could be seduced and that could be made to serve the old gods even from places, god help us, from places like Chicago if absolutely necessary. To take people from Chicago, to find the monsters that can lure some soul from Chicago and take such persons to the murky and forgotten zones of lost time. If you can smell Vétheuil in your mind, it should be the smell of the cellar, the smell of certain kinds of mold and of lichen on wet stones.

One thing about Jean-Paul Riopelle is that he surely knew how to screw and that was important to Joan Mitchell. She wasn't goofing around when it came to screwing. She liked people who took their screwing seriously, and it seems that one of the skills of Jean-Paul Riopelle was the ability to put a fair amount of energy into screwing. There's a black-and-white picture of Jean-Paul Riopelle standing against an abstract painting in the background, and there is something in Jean-Paul Riopelle's eyes in that picture. He's looking off to the side, not directly at the camera. He looks a little like an animal to me, a beast. He's on the older side in the picture and his shock of tremendous hair has gotten

Back to Joan Mitchell and the intractable France problem

stringy. That stringiness makes him all the more beast-like. Scary. Scary, big features. Fleshy features. He's looking off to his left and that gaze manages both to be calm and fierce at the same time.

That's the sort of person, the sort of half-beast who could really take me on, Joan Mitchell may have thought. I'm projecting a bit here. But there is reason enough in her actions and in her letters to think that Joan Mitchell liked what I am calling the beastliness of Jean-Paul Riopelle. He did things big. He had a knack for the large gesture. Joan Mitchell liked that. She liked his wildness and the fact that he knew how to take a body downtown, as Lana Del Rey might put it. He could dress up nice and take you downtown, literally. A trip downtown in the Bugatti wearing long white scarves and putting the goddamn show on. He could do that. He had the energy and the panache. And then after the party, he'd chew the dress he bought for you right off of your body. He'd take your body downtown in the other sense. His beastly teeth would tear the cocktail dress apart. I'm guessing here, but I bet I'm not far off. I'm imagining things. I'm imagining Jean-Paul Riopelle in a beastly state tearing Joan Mitchell's dress straps apart with his teeth.

And then he wrote letters. Joan Mitchell would get sick and disgusted with Jean-Paul Riopelle and would go back to Chicago or New York City. I can never keep the timelines right in my head. What does it matter anyway? She would go to France and then back to the US and Jean-Paul Riopelle was always mixed up in the story. The beast was always lurking in her mind, lurking

in her, lurking. Jean-Paul Riopelle had some hold on the loins of Joan Mitchell but it wasn't just that. He had her loins and his sharp animal teeth that could tear at her dress straps. But he would write her letters. Beckoning her back. Pleading letters. Or insanely angry and threatening letters. Or coyly manipulative letters. He would pluck every string.

Those letters would set off rages in the mind and spirit of Joan Mitchell, and without all this game-playing by Jean-Paul Riopelle it is hard to imagine that Joan Mitchell would have been able to keep going back to France and finally to let Vétheuil get its more subtle hooks into her. Because who was going to continue the project of Impressionism other than Joan Mitchell? Who was going to wrest abstraction away from the formalists and bring it back to the poets other than Joan Mitchell? Who was going to return to Impressionism other than Joan Mitchell? Who better? Vétheuil itself somehow knew this. The ghost of Monet and his dead wife Camille somehow knew this. And they sent out their beast, their Caliban, their secret weapon. And that Caliban was named Jean-Paul Riopelle. His sacred task was to capture the rich girl from Chicago and make her something new and, at the same time, very, very old and terrifying in the moldy old town of Vétheuil. The sacred task of Jean-Paul Caliban Riopelle was to trick Joan Mitchell into the worst and most nonsensical decision of her life. To go the wrong way. To cancel history. To choose the wrong path. To become lost. To fail. To descend into hell. To be destroyed. To continue

Back to Joan Mitchell and the intractable France problem the otherwise discontinued project of Impressionism. Embarrassing.

So, Joan Mitchell was being pursued by ghosts and by ancient forgotten things lurking in the shadows of Europe and by lost time and by Monet and his dead wife—dead wives, actually, but we'll get to that later—and by the death of Monet himself and by death itself, the death that is the true subject of Impressionism and the true subject of everything of worth that Monet ever painted.

Perfect.

11. A few more brief thoughts on loss and death.

WHEN PEOPLE ASSOCIATE Monet with a place they always think of Giverny. And why not? That is the place where Monet settled down to make his water lilies and to notice, over and over again, a certain kind of light on a certain kind of pond. Giverny is the place of Monet's triumph, you could say. Giverny is what was given to Monet, but only given to him after the hell of Vétheuil. Because it was Vétheuil that made Monet into Monet. And this was nothing pleasant. Monet had to be destroyed in order to finally claim his Giverny. That is the simple fact of it. He had to go down into Vétheuil and get wrecked. And this was something that happened to him. He didn't choose it. These are never things that are chosen. They are given. They are suffered. For Monet, it had all to do with the death of Camille, his first wife. She died rather horribly in Vétheuil of uterine cancer. Claude Monet and Camille lived together in Vétheuil with a son or some other children, I don't know, it doesn't really matter. These were the days in which Monet was trying to figure out what he was really doing with all that light and the Impressionisticy moves

A few more brief thoughts on loss and death

of Impressionism. He wasn't sure what he was doing really, and his wife was being pulled away from him, fading away into the hazy places between life and death.

That is where Monet learned, truly learned to paint. Don't you see? He learned to paint in the land of the dead. He learned that painting could be a medium for showing the true passing away of things even in their presence. This is the true triumph of Impressionism, though no one wants to name it as such. The truth of Impressionism is death. There has never been such death-obsessed painting as the painting of Monet. That is the greatness of it. All the stuff about light misses the point. Yes, there is light. But fuck light. It is death more than light that makes the paintings great. The light would be downright stupid if there wasn't so much death in it.

12. Going to hell. Lots of people have done it. Odysseus did it. He did it because of Circe. And what does any of this have to do with Poseidon? What do the depths conceal?

TO GO TO Paris in the late '50s and early '60s, if you were a painter in the New York School, was essentially to go to the land of the dead. And that was exactly where Joan Mitchell wanted to go. Except, of course, that she didn't really know that and didn't really want that at all. Who wants death? But she did want it. In the deepest ways, she wanted it. She wanted to go to the land of the dead because she wanted to die in some sense, is what I am saying, even though it may seem like a shocking thing to say. She did not want to die physically, of course. Though, it should be said that sometimes she did want even that, to die physically. Who doesn't? Sometimes it seems best just to die. That would be easiest and best. A relief. Perhaps the best thing for human beings is never to have been born at all. But having been born, the next best thing might be to die quickly. It is possible to have that thought. It is a thought that has

Going to hell. Lots of people have done it been articulated, now and again throughout history, by those with enough courage to think it through. The going to Paris and then eventually to Vétheuil was the sort of act that we might call suicide. Can we say that? It was a descent into hell, with no offense to the French. But in this case, it is France that provides, for Joan Mitchell, the role of the underworld, the place one goes to in order to burn up. And Jean-Paul Riopelle was simply the guide for Joan Mitchell's descent into hell.

Why does a person ever go to hell in the first place, though? Why would anyone want to make a descent into hell? Well, the answer to that is actually pretty easy. You make a descent into hell because you want to find something there. Odysseus, for instance, makes a descent into Hades because Circe tells him to and Circe is the sort of person, or sorcerer, or whatever you call her, to whom a person would be well-advised to listen. Circe tells Odysseus to go to Hades because he might find Tiresias there and finding Tiresias is always a good thing because Tiresias is a prophet and prophets are the sort of people who see further and deeper than other sorts of folk. They have the gift of revelation. They reveal things, usually to the dismay of the people who want something revealed, since the people who want things revealed usually have some stupid agenda, something silly that they think they want, and the prophet usually lets the ones who are seekers know, in some sneaky manner, that life, in fact, is not about getting hold of the things you think you want but about being completely destroyed as a wanter and coming out the other side

either as a complete wreck or as a new sort of person who has had their wanting completely and seriously reordered. So, you go to Hades to find someone who will help you die. You go to Hades to find out that the shit you think you want is utterly ridiculous and that you are a fool. You are then encouraged, by a prophet or some other sort of dead person down there, to give up on the life that you thought you had up top and to die to yourself and to be reborn as something else, someone else, still the same person, of course, in all the outward ways, but also completely transformed. Exactly who you were and also exactly and completely not yourself.

That's the kind of trip Odysseus is on and the kind of story that is really being told in the Odyssey.

So, Odysseus and his men draw their ships up and they go down to the bright sea and are sent good winds by the dread goddess with lovely locks. This is Circe, the kind of person who can send you to hell, the kind of person who would understand a thing or two about Jean-Paul Riopelle. Circe is described literally as a "voice haver"—that's what Homer calls Circe, he calls her *audeessa,* which means one who speaks, that's the sense of the word, this word is about speaking. Circe speaks, and she speaks in ways that can be understood and yet, at the same time, the things she says are from the other side. She speaks in ways that Odysseus can hear, literally, in the language of Odysseus, in ancient Greek, but the things she has to say, these things, these speakings, are of an oracular nature, they are signs and

Going to hell. Lots of people have done it

hints from somewhere else. That is the special nature of Circe, one might say. To be *audeessa*. To be a bridge.

Language as a bridge, a thin rope that connects the seen and the unseen, life and death, what is limited from that which is unlimited. To bring human persons across boundaries and to bring the things of the divine over the boundary and into the worldliness of the world. And isn't that what her power does in turning men to swine as well? Because that is another supposed boundary: the boundary between human and animal, man and beast. Circe messes with that boundary, too, by turning the sailors into swine. Doesn't she want to show the menfolk, the persons around Odysseus, the crew of the nameless ship, the boundaries and limits of being human, of being the rational animals that they supposedly are? The answer is yes, she does. And so she makes them into pigs. She piggifies them. But the main thing that Circe does is to tell Odysseus that he has to go to hell. He has to die a little. He has to make his way to the underworld and to find a person in the underworld who still knows how to dredge up a language that can pass over. And that's what Odysseus does, he goes to die a little and he goes to find the man who can speak a language that is from the dead but that still has the power to pass over into life. Odysseus goes to hell in order to find Tiresias.

And what does Tiresias in fact say to Odysseus? Basically, he tells him that the journey home is going to be a shitshow from start to finish. He tells him that the gods are going to make things hard for him, especially

The Grand Valley

the rather petty and spiteful Poseidon, and that the crew, with all their wild desires, will make things hard for him and that, finally, in essence, the attempt to go home is going to be ruinous for everyone involved.

What does it mean, by the way, to be opposed by Poseidon? Poseidon: the god of the watery underworld and of the shakes and quakes and rumblings that come from the insanity of the deep. To have Poseidon as your foe means you have, in essence, the very depths themselves, the roiling depths, as your enemy. Which really means you have your own self as an enemy, the deep self, the self that lurks around down there and has long chats with shadows. Fighting Poseidon means that you are trying to stay on the surface as best you can and that the roiling depths are trying to drag you down, to show you something below, to bring you down.

But you don't want to go down there. You don't want to encounter the parts of the self that are, in a sense, everything else, everything that is not the surface self. So what Tiresias is really saying to Odysseus is that you can't go home again because you don't even know who you are, and so the "you" that goes home will not be the you that left, and not only "you" will change and has changed, but nothing is ever really what it is and therefore never stays the same thing that it seemed to be in the first place.

This is a message from the Deep. You can't go home again because the you that goes home doesn't exist and the home doesn't either. Tiresias tries to show Odysseus that the problem of going home is not a logistical

one, that it is deeper than logistics. Does Odysseus learn this lesson? That depends on how you read *The Odyssey*. That depends on what story you think is being told. That depends on whether you think Odysseus is really trying, truly engaged in the project of going back to Ithaka in the first place. *Polutropos*, Homer calls Odysseus right in the first line of his poem. The man of many twists and turns. The man who will turn every way he can but down. The man who wants to remain himself despite every indication that the only way truly to discover oneself is to surrender oneself. Does he ever straighten out? Is that the goal, to straighten out? Or is *polutropos* naming a condition? Is there a Big Odysseus and a Little Odysseus? Let's just say that Odysseus both does and does not succeed in learning anything about himself, that he both does and does not return to Ithaka, that he is, like all of us, a contradiction and a mess even unto himself.

13. Some further thoughts about Jean-Paul Riopelle. The beast plays his role and runs off with the dog walker, as was also necessary.

PERSONALLY, I'VE GOT my problems with Jean-Paul Riopelle, as may already be apparent. I want to protect Joan Mitchell from Jean-Paul Riopelle. I want to intervene. Why did he put so much paint on all his canvases? Just stop, sir. Let the canvas alone. You're murdering it. But he never could stop slathering his canvases with paint. It is somewhat amusing though, in an upsetting sort of way, that Joan Mitchell protected herself from the drippings of Jackson Pollock and then fell into the arms of a canvas-murdering slatherer like Jean-Paul Riopelle. This was a man who could not consider a painting finished until it was ten or fifteen pounds heavier than when he started. He painted by weight.

Joan Mitchell fell in love with him anyway. The sheer cad of the man was too much for her. She loved the fact that he was a scoundrel and that he had a Big Jean-Paul who was the equal to Big Joan. None of this matters so much. Let Joan Mitchell make whatever terrible life decisions Joan Mitchell wants to make. Let her

Some further thoughts about Jean-Paul Riopelle

scream and fight with Jean-Paul into the late night hours at some Parisian bar, and let them beat one another with their fists and then fall into bed later in a drunken tumble of tears and screwing. We can let them have this. We must let them have this. It is theirs to have since they already did it. They put all that into the historical record by doing it. They made it real.

In many ways, I'm glad for the Jean-Paul Riopelle years because it gives a kind of explanation to that period, mostly in the 1970s and sometimes early '80s, where Joan Mitchell lost her way as a painter. She started filling up the whole damn canvas. She had resisted this game for so long. And then, in the 1970s she broke down. She succumbed to the entirety of the canvas, as if that mattered to her suddenly, as if it matters that the canvas is this size or that size, and as if there is some kind of painterly duty to get paint on every inch of the thing. But of course Jean-Paul Riopelle was finding a great deal of success, at least in those days, doing exactly that—creating, pound for pound, some of the heaviest paintings the world had ever seen, layering layer after layer over every inch of the canvas—and Joan Mitchell, despite herself, despite being fierce and stubborn and the violently self-possessed sort of person that she was much of the time, despite all this she was influenced by it, influenced by the confidence, I suppose, that oozed from Jean-Paul, and that he could fling around simply just by being a man of his time, probably, if nothing else, and by being a sort of toast of the town in the days that he was a toast of the town.

The Grand Valley

That paint slatherer had a real influence on Joan Mitchell. She made paintings for some time, for roughly a decade, that got themselves all over the canvas, over onto practically every inch of it. She could never bring herself—thank god, still being Joan Mitchell and having the scritchy and the scratchy deep in her bones—she was never able truly to slather on the paint in the way that Jean-Paul Riopelle loved to scrape and pour it on. Nevertheless, the paintings that Joan Mitchell painted from the mid '70s into the '80s have entirely too much paint on them, by her own standards, and she tried to cover too much of the canvas, in my opinion. It should be mentioned, by the way, that Jean-Paul Riopelle painted his best paintings after having met Joan Mitchell and after having learned from her that he didn't have to use so much damn paint all the time. A bit of restraint enters into his paintings over those years, the Joan Mitchell years. So, she improved his paintings and he worsened hers. It's the old story. Woman meets man. Woman tries to fix man. Woman loses herself in the process. Man runs off with the dog walker. Woman finds herself again.

In 1979, Jean-Paul Riopelle really did run off with the dog walker and that was the end of the story between Joan Mitchell and Jean-Paul Riopelle. It took Joan Mitchell a few years to get the Riopelle-inspired, painting-by-weight tendencies out of her system and go back to painting like Joan Mitchell. Except that those last paintings, the paintings from the mid-1980s until 1992, when she died, are all a good deal brighter than

Some further thoughts about Jean-Paul Riopelle

the earlier paintings, the paintings that came before the Jean-Paul Riopelle detour into slathering. They have a different feel. They are truly paintings unto death, I want to say. The paintings get lighter and airier and then she dies.

So she never exactly went home again, in terms of painting. She never returned completely to where she'd been. That doesn't happen. Tiresias reminds us of this. But she returned to the territory she'd inhabited before the Jean-Riopelle years. She both went back and she didn't go back. And it should also be said that she never changed all that much as a person. She remained a terrible drunk until her last day. She basically drank herself to death and there were a lot of pills involved too. She was angry and bitter until the end. She was violent and she was cruel and she was abusive toward everyone around her until the very day she died. She was combustible to the end. She never learned a thing. She harmed herself and she harmed the people that she loved and she was in terrible pain, I think, a terrible kind of pain that was constantly with her until the day she died.

If she went to France in order to make a descent into hell, it could very well be said that she went to the underworld and never came out. Maybe she'd been there all along. She was at war with herself and with the world around her from the time she was a little girl in Chicago, you could say, and the only thing that ended that war was death. She went down into hell early on and she never emerged. She lived life as if it were a battle

The Grand Valley

in the fires of hell. And if that, in essence, is what Dave Hickey meant when he said that the Big Joan / Little Joan stuff is complete baloney then he has a point. The paintings of Joan Mitchell come out of Joan Mitchell's battles in hell. There is truth in this statement.

It would be a disservice to this battle and to the dignity and genius of Joan Mitchell to pretend her life was anything other than what it was. Joan Mitchell didn't even know why she was painting much of the time. It disgusted her. Or bored her. And all that disgust and dissatisfaction and boredom is there on the canvases. That is life. That's what Joan Mitchell had to offer and that's what she did offer. That's what Dave Hickey has been trying to tell us about Joan Mitchell and he is not wrong. He is not wrong at all.

14. The wrongness of Dave Hickey even though he was also a little bit right. Also, the letter "S" is red. And the importance of paintbrushes, lots of them. The way that Joan Mitchell went within herself and then beyond herself when she was alone with her brushes.

BUT DAVE HICKEY is, also, completely wrong about Joan Mitchell. The real point of Little Joan is that she'd discovered something. She discovered something real about being a person. Being a person, she'd discovered, is a strange thing indeed because you're both you and not you. And the not-you-ness of you is something that can be constantly discovered, and when it is discovered it is clear that that not-you-ness is you as well, maybe more you than the you that you thought was the real you-ness of you before you began to touch upon the not-you-ness of you.

Can you just get rid of being who you are altogether?

The Grand Valley

If only. If only that were the case. The comedy and the tragedy is that the being-who-you-are is a little more intransigent than that. God knows it doesn't exist. That's the problem. Sure. The more you really look for the being-who-you-are the more it dissolves. It is a nothing. Of course. But it is the hardest, most intractable nothing out there. It is an utterly resilient nothing. It always comes back. It always finds itself even though there is nothing to find. The individuation process, as our Swiss friend Carl Gustav Jung would say, is not in the category of reversible things. It matters not for how many years you meditate or nap or whatever. The being-who-you-are returns. It is the great returner. Even though it is nothing and has no substance and no location, cannot be grabbed hold of or defined or isolated, is really and truly a nothing, is mutable and malleable and in constant flux, even though all these things are true, the being-who-you-are is, also, completely and totally present, and relentless as all hell.

I say this because it would be easy to put the drama of Big Joan and Little Joan into the story of getting rid of being-who-you-are and turning into an absolute who-it-is. But that's not going to cut it. It is not the case that Big Joan is the being-who-you-are and that Little Joan is the being-beyond, the being-beyond that comes out to paint when the being-who-you-are can be put away. There is, maybe, a little bit of truth to this picture but only in the most simplistic of ways. Mostly it is not very helpful. Because, in a sense, Joan Mitchell became most herself when she came out to paint. There was nothing

so Joan Mitchelly as Joan Mitchell standing in front of a canvas with a paintbrush. And yet, at the same time, this Joan Mitchell in front of the canvas was at the service of other forces. She was there being Joan Mitchell totally and completely and, paradoxically (but is it a paradox?) most deeply not-herself or at-the-cusp-of-herself in those moments too. The problem of being-who-you-are does not go away with Little Joan, to put it another way.

Joan Mitchell, it might also be mentioned here, was a synesthete from an early age and until the day she died. That's to say, she experienced an overlapping of the senses. Senses that tend to be separate in most people were not as separate in her. This happened especially with colors for her. The letter "A," for instance, was, to Joan Mitchell, always green. She just saw it as green. The letter "S" was red. So the word "sea" started out as red for Joan Mitchell and then softened into some green at the end. The colors of letters and numbers were simply obvious to her. The world just looked that way. Even people could possess certain kinds of colors for Joan Mitchell. Or a blending of colors. The colors went along with feelings, or a range of feelings.

There is an obvious thing to say here. Joan Mitchell experienced the world as having fewer cuts than the rest of us tend to experience. Fewer boundaries between this and that. Less individuation you could even say. A kind of hovering unity or a blurring and overlapping of areas and zones of experience. When Joan Mitchell was standing in front of a painting she was seeing those colors in the way that a synesthete sees colors and she was

listening to her music, Bach or Billie Holiday or whatever, and she was seeing things in the music and she was working that all together into the colors on the canvas. That's why I am saying that she was never truly going to be a paint slatherer like Jackson Pollock or Jean-Paul Riopelle. It's the color, not the paint. For some Abstract Expressionists it was the paint more than anything. The color was just further proof of the substantiality of the paint, that the painting was real, the color helped to show that the paint was really there. The reality of the paint was the true goal for many of the Abstract Expressionists. For Joan Mitchell, however, the paint was just the thing that carried the color. If she could, somehow, have painted in pure color and gotten rid of the paint altogether, I think she might have done that. The paint was simply a convenient vehicle for the color, which was the whole deal for her, for Joan Mitchell. Joan Mitchell was grateful to paint since it was a vehicle by which she could get color on the canvas in all sorts of ways. But that's it. The gratitude ended there.

Just look at *Girolata Triptych*. There are some spots, down in the bottom of the right-hand panel, for instance, where, I'm pretty sure, she put her finger in some paint and then put her finger on the canvas. She just fingerpainted that part. I mean, there's no shame in that. Titian was a finger painter, especially in his later years. A lot of great painters become kindergartners of sorts. They get right into the paint with their fingers and they smear it on the canvas. There are a few drippy parts of the canvas, especially in the middle panel on the bottom

left. There are some smudges, how did she get those? Maybe she rubbed the paint on with a sponge, or some fabric? I don't know. Then there's the scritchy scratch of various brushes. It was important to Joan Mitchell to use lots of different brushes. She had a contempt for painters who only used one brush. It made no sense to her. Sometimes she knew that the color had to go on heavy and sometimes it had to go on lighter. Sometimes it had to be very fine lines and other times smears and daubs. Some spots needed to be dense and layered and bottomless. How are you going to do all of that with just one brush? Idiotic. You need hundreds of brushes and other kinds of applicators too and sometimes just your own frickin' hand is the only thing that will do. She would probably have used the faces of her victims to smear paint onto the canvas if she could have gotten away with it. The severed hands of idiots who had pissed her off the night previous. All of that. As it was, she had a ton of brushes and she had sponges and rags and whatever else, and she had her own fingers.

The fact of Joan Mitchell being angry at and contemptuous of painters who don't have a lot of brushes is telling us something about what Joan Mitchell thought a painting was supposed to be. The paintbrushes thing may seem like an amusing anecdote. Joan Mitchell being an asshole again. It is that, of course. Joan Mitchell was always finding a way to throw a little bile into the world. So she is being catty here, baring her claws at all the other Abstractionists who have no idea really what they are doing standing there in front of the canvas with the one

stupid brush that is somehow supposed to do the whole job. A monumental task at hand and there you are with one single brush in your hand like somehow that is going to be enough. That idea made Joan Mitchell angry and it made her laugh. Because the task, for Joan Mitchell, was to get at something so elusive as not to be talked about. She was clear about that all the way down the line. She was clear about not being clear. She would throw out a morsel here and there. People grab onto those quotes. We've already noted a couple of them. Joan Mitchell would say things, when pressed, about painting being a remembered feeling or the repetition of a memory or various riffs on that theme. These comments are helpful to some degree. There's an important insight there, that every one of Joan Mitchell's landscapes, if we can call them that, are documents not of a landscape, whatever that is, but of the memory of a landscape, or the feeling of the memory of a landscape.

The important thing to note here is that she is not interested in visual experience itself. She's not after the immediacy of visual experience right there as it hits the eye or the brain or the sensual apparatus or whatever it is that visual experience hits. Some painters are after that kind of immediacy, it should be noted. But not Joan Mitchell. She was after something else. And it basically pissed her off—the attempt to explain what she was after mostly just started to piss her off. You can see that in the movie *Joan Mitchell: Portrait of an Abstract Painter*. You can see that when she gets pressed too much in the direction of putting words to what she's after. A hardness

begins to set in on her features. The combustible in her is starting to get roiled up. It's a danger zone.

What's clear when you look at a Joan Mitchell painting is that she worked on the canvas for a long time. Or let's say she labored at it. I don't know what it took in terms of person-hours, actual physical time spent in front of the canvas. That doesn't matter so much. But the point is that she labored and worked at painting. Her paintings can look dashed off when you first glance at them. They can look like maybe she just threw some paint at the canvas and that was that. But the more you look, no. She was putting something together, and it is clear that something had to be gotten right. Something was at stake there, on this canvas. To get it right was a big deal. The fact that Joan Mitchell went after her canvases with knives and ripped those fuckers apart, which she sometimes did, gives you the sense of urgency. *Girolata Triptych*, for instance, is about getting something right. The Grand Valley paintings are about getting something right, though in those paintings it is even less clear exactly what the original experience is, which makes the "getting it right" part even more wonderfully hazy. She would have kicked a hole in any of these paintings and thrown them out the window, probably, if the paintings had not gotten it right.

But *Girolata Triptych* is right and the Grand Valley paintings are even more right for the very reason that they create their own conditions for being right since they are the establishment of the very world they are meant to portray, without, of course, exactly portraying

anything. The paintings that get something right for her survive her wrath. That's why the scritchy scratchy is so important when it comes to Joan Mitchell. The different brushes where she can just do a little scritch here and then a little scratch there. Just the right size, just the right thickness, just the right faint hint of a line here, the little hint of color trailing off over there. These scritches and scratches weave together into an ambiance, I want to call it. That's what the Grand Valley paintings are all about. She scritches and scratches her way into imagining what the place is like, what it must have been like, what it always must be like. A subtle weave of an ambiance is getting worked up as Joan Mitchell moves in on the canvas with all her brushes and a scritch here and a scratch there. All the while, that heavy presence of paint and those presences are deepening on the canvas as she adds some more green, some more black, a little swizzle of orange, a little swizzle of pink, then more black and more green or blue or orange again.

Something is being worked up with great labor here. Something has to be the way it has to be. Joan Mitchell, in these moments when she is standing before the canvas and jabbing and dabbing at it, is when she almost merges into certain aspects of a memory or an imagination of an experience, this quasi-remembrance of the experience of a place and a time and a just-so of the way that it was. And then again, the thing is totally and completely subjective too. It is the her-ness of her that she's painting in that scene. But not her. Not her because it doesn't really matter what the particularities

of Joan Mitchell are in the biographical sense as she is scritching and scratching at the feeling of a memory or even the creation of a memory that becomes a memory by painting it.

A lot of things that would seem to matter about being a person fade away here. Something else is emerging just into the cusp of experience. But what is it? The just-being of the presence of the sense of what it is like to be the sort of presencing before a happening of something else, but also not just "something else," something specific, something that could only have happened on a certain day in the Mediterranean or with children playing in a secret place, or of something happening at a certain time to a certain person, and yet there in a kind of absolute and shimmering presence of what it is, which is what it is no matter what, and is capable of penetrating into all of us all the time, but which is only here and only now in this case. But that doesn't really say it of course. That won't do at all. There's a feeling and a happening, that's all, and it's been made real.

15. On the nature of the self, which has no nature. On the paradox of the self, which isn't even a paradox, because it is nothing. The something of a nothing. The importance of music. The importance of the sound of certain human voices. The infinity of certain experiences.

JOAN MITCHELL FELT her emotions. Throughout her life she definitely felt her emotions. Was she doing the feeling or was the feeling being done to her? Because emotion isn't exactly something that a person decides to do. That's to say, no one suddenly decides to have an emotion and then has that emotion. You don't say, I'm going to feel wretched today, or exuberant, or hello, today I'm going to feel a light and dangerous sense of insubstantiality and thinness but I'm also going to feel resonantly alive in this thinness. That's what I'm going to feel today.

I mean, one can do the sorts of things that help to bring on a certain kind of feeling, a certain way of being

On the nature of the self, which has no nature

in the world. Perhaps there are songs that do this, that help bring on a way of being in the world. There are external factors. Times of day, or the way that the light falls upon objects in the world, these might be important for bringing on one set of feelings versus another. It may be completely impossible, for instance, to listen to the song "Please, Please, Please Let Me Get What I Want" by The Smiths without feeling just the sort of intangible thinness of being a person, and the sense that one's thinness is spreading out, drifting out over the room that you happen to be in, and as the thinness spreads out to feel that you are both losing yourself and gaining yourself at the same time. This song may simply have the properties that increase the possibility of that sort of feeling.

Or it may be next to impossible, for instance, to listen to "Pavane for a Dead Princess" by Maurice Ravel, especially the version as it was played by Sviatoslav Richter, who plays it with the necessary slowness and the hang-dog limping quality, and then rushing ahead moments and the banging down almost at certain spots that other less-Russian pianists seem to be incapable of achieving, and there are many quite talented pianists who nevertheless play Maurice Ravel's "Pavane" like it is either some kind of fluffy romp, which it most certainly is not, or like it is some tiresome dirge, which it also most certainly is not, while, on the third hand, Sviatoslav Richter plays it like, I don't know, as if almost there is a certain amount of glue on the keys of his piano and he must fight slowly and resolutely

through the glue in order to get the song out. Whatever it is, exactly, that Sviatoslav did to his piano—and there may have been a certain amount of glue or other sticky substance involved—it creates that just right amount of plodding and then freeing up and dashing forward and then the sinking back into the glue that the song by Maurice Ravel demands and which inevitably induces a feeling of what, exactly? A feeling, I suppose, of the strange happiness that comes from sadness, the buoyant and guilt-ridden joy that lingers at the edges of grief and is, in fact, only possible in certain stages of grief and of mourning. You almost want people to die sometimes, you can almost find yourself wishing that people you otherwise love and care about will die just to create that feeling of the horrible sinking overwhelming weight of grief that then suddenly lightens up into moments of indescribable percolating tingling joy, the saturating joy that lingers only and ever at the edges of the deepest grief. That's what Sviatoslav Richter squeezes out of Ravel's "Pavane" in his gluey dance with death.

Or perhaps it is a song by Skip James, almost any of them will do, since all you need is the specific timbre of Skip James, the voice of Skip James, the specific wailing of Skip James—neither quite mournful exactly, though there is mourning in it, nor just weeping nor even just a wailing, though there is also a fair amount of weeping and wailing, but more even than the mourning and the weeping and the wailing is the just little hint of celebration that is going through his voice at the same time he is a-weeping and a-wailing and pulling out all sorts of deep

On the nature of the self, which has no nature

sadness from down within his vocal cords and yet, at the same time, the real trick of this kind of Blues singing, the trick that is not always understood or appreciated even by the people who want to appreciate the singing of Skip James or of other Blues masters, is that he is also having a good time. Here is a sort of celebration of the heartbreak and the suffering and that this bitterness is being lapped up in the voice of Skip James, it is being taken in and savored, this savoring being the very thing that those who dwell on the hard times and the lament that is, obviously, being voiced by Skip James are missing and those who want to hear the Blues as just sad, which is not quite the point, those people are not allowing the full depth of what Skip James has to express, the depth of his savoring, in a song like "Cypress Grove Blues," his savoring and even the little smile that curls around in his mournful voice when he sings of preferring to be buried in a cypress grove than to be treated in the way he is being treated, the only way really to listen to a song like "Cypress Grove Blues" is to hear the celebratory savoring that nimbly flitters about on the edges of his weeping and wailing and which is inseparable from the lonesome shimmering of his vocal timbre.

The point here is simply that emotion, feeling, whatever word you want to use, this is something that happens to you. One is passive, in a sense, in the face of feelings. Of course, that is wrong too. It is never complete passivity. It's just that a feeling comes upon you, it has its way with you, you don't have your way with it—not at first, at least. You might have your way with

a feeling after it has first had its way with you. But the world of feeling is the world in which the being-who-you-are is buffeted about, riding on the oceans of all that is beneath our conscious willing in any direct sort of way.

How often do we honor this basic fact of being alive? How often do we actually stop to consider and admit that quite a massive chunk of the time spent being alive is just riding the tides, as it were, of the various waves of feeling and impulse that are stirred up by God-knows-what at every moment of the day or night, even in our dreams when the waves of thoughts and feelings are unloosed even further than in waking life, and the sea of night can simply be a giant series of feelings that come one after the other, and the conscious parts of our mental apparatus are only somewhat able to keep up with these waves of feeling and so simply attach whatever narrative might be ready-to-hand, and the waves of feeling get grouped up with all kinds of roiling images and scattered narratives trying as best they can to accompany the waves of raw feeling and emotion. How many times a day does the day shift for you? And why does it shift? It shifts because maybe even just the way that a cup is sitting on the edge of a table creates a kind of angle and a tension-of-being that is suddenly in the room and this tension-of-being is just so, maybe because of the color of the cup and that specific color against the wood grain of the table, and this specificity of color and grain and tension-of-being that is suddenly created in the room, this tension-of-being is exactly the

On the nature of the self, which has no nature

feeling from another time in life, even though there is absolutely no possibility of consciously recollecting that other time, the time is lost, completely lost except for the fact that it still exists as an imprint on the soul, and this imprint will always be there, and so when the color of the cup resonates against the grain of the wood and creates a certain sort of tension-of-being in the room, and this tension creates a situation in which a portion of your soul is activated regardless of whether you understand it or not, and of course you will not understand it, since it is a reality inaccessible to understanding. It cannot be thought because there is no thought there. There is only a kind of imprint on the soul, a divot in the soul that sometimes a specific tension-of-being fills up in just the right way. This is something that's going to happen to you. It happens to you. You don't make it happen. It happens to you. But you also participate in the happening, since you start reacting to and dealing with the feelings and emotions as soon as you start having them.

Or let's talk about the lighter and sillier ways that one is buffeted about all day long just by the way things are. A person laughs and it annoys you. There is a reason for that, but you will never uncover it. The sunlight hits the windshield and suddenly a feeling of well-being floods your heart. It happens and passes, and you never even took the time to register the fact that it happened, but the next hour of your life exists under the grace of this random event that affected you as it did for reasons so lost in the hither and thither of memories and happenings and events that there is no way to trace the near

infinity of intersecting hithers and thithers and even so, such as it was, the next hour of your life will be held in the palm of the grace of this random event and will, in fact, be passed on from you to other people in your easy and gratuitous smile and the gentle kindness of your speech and the patience that is within you and flowing from you in that hour of random grace that touches lightly upon the being-in-the-world of various other creatures that will pass through your hour of random grace, the indefinable aura of the hour of grace that was given to you simply because the light of the sun happened to hit the glass of the windshield just so, just the specific way that it did. Or a dog barks and you didn't even actually notice it but some part of you did notice it and a fear was dredged up, just an inchoate sense of fear that, as far as your awareness is concerned, came from nowhere and yet from that moment on, for the rest of the day you will proceed in a slight haze of fear that has no amplitude and no cause that you can understand but which colors each action and each reaction is the ruling emotion of the entire rest of your day and is as baffling to you as it is to everyone else.

Where is the subject in all this, where is the being-who-you-are? It is nowhere, of course. But it is also very much there, in the barest fact that we are always somehow aware of ourselves and about the various happenings of the hither and thither as happening-to, there is a happening-to, and so the subject, the self, the being-who-one-is is maybe, if nothing else, at least a kind of locationless location in which we can assert

On the nature of the self, which has no nature

that all of this hithering and thithering and dithering is a happening-to. And yet, at the same time, there is nothing stronger than this sense of self that emerges and palpitates almost, that shakes and trembles in the face of the tensions of being that come from the cup and the wood grain or from the voice of Skip James or of Billie Holiday or that come of looking at the hovering mass of colors at the center of one of the Grand Valley paintings.

What I want to say is that Joan Mitchell herself—the specificity that is the person Joan Mitchell—exists on that canvas and all over that canvas, and it makes no sense, even as one encounters the absolute sense of space and color and being-for-the-sake-of-being that obviously exists on the canvas, even as one encounters all of that, one also encounters this very specific person, Joan Mitchell, herself experiencing the being-of-being that came to her that one day on the coast of Corsica or in her imaginings of children playing somewhere in France and which made a kind of divot in her soul, and where and when something happened to her over which she had no control but that she nevertheless threw herself into, that she chose to be her experience even as it simply became her experience without her having any choice in the matter. It chose her and she became that moment, and then she allowed that moment to pass into her own soul, furrowing a divot into the soul-place that she had available on that whatever afternoon. She was able to nurture and hum along with that soul-divot and then finally, in nursing its space and contours in her

own soul, was then able to pass that along in the just-right marks of scritches and scratches and finger smears and brush moves. And that being, that specific tension of being that happened to Joan Mitchell and that passed through Joan Mitchell, was marked and made known to her and passed onto the canvas like fire, like a chain of lightning that blasts and sears its way through different particularities, different subjectivities that belong to me or to you or to anyone else, all of us who stand before one of the Grand Valley canvases can be seared by the lightning blast of a specific sort of experience that came upon the person Joan Mitchell on the day that it did in the place that it did.

16. Joan Mitchell sees the direction in which art history is going and runs in the opposite way. Joan Mitchell feels sorry for herself after Jean-Paul Riopelle runs off with the dog walker. Joan listens to opera. Opera leads to considerations of some of the great fuckfests of history.

PERHAPS ONE OF the reasons that Joan Mitchell went to France is that she knew how important it was to be close to things that have already passed away, and that being close to that which has passed away meant, for her, that she was close to the line between the being-who-she-is and the being-beyond-and-more-than-who-she-is. That place is a place of magic but also, therefore and necessarily, a place of death. She wanted to be in that place. But she was also afraid of death. She was often afraid of death. In her later years, in the mid-1980s when Joan Mitchell was diagnosed with a cancer of the jaw, it looked as if she might have to have her entire jaw removed, which scared the bejeezus out of her you can

be sure of that, and it is hard to imagine a more horrifying prospect, a more horrifying choice to have to make than deciding whether or not to allow doctors to actually remove a large portion of one's face. In the end, Joan Mitchell was able to undergo a series of radiation therapies that were successful in stopping the cancer for a time and that allowed her to keep her jaw, though this jaw was now sucked of its essence you could say, was brittle and almost a dead thing on her face, and it is said that for the remaining years of her life, which were not many, there was often terrible pain in Joan Mitchell's jaw and often the fear that this now dead and brittle thing, this thing that had been zapped by rays and was sapped of its essences, was always in danger of snapping and had to be dealt with gingerly, and one can often see in pictures and in film footage of the late Joan Mitchell that she is holding her jaw and cradling her jaw as if it is a thing that might disintegrate completely.

France does not represent death for everyone, it should be noted. This would not be fair to France. The deathiness of France is a relative thing. France was death for Joan Mitchell because Joan Mitchell was born an artist in the ferment of America after the war. The whole point of being part of the New York School of painters and poets was to say no to France, was to declare the definitive death of France, France being primarily of course Paris which, for much of the early part of the twentieth century, for the first half of the twentieth century, was more or less synonymous with the term avant-garde. Just to say the word "Paris" in the 1920s or

Joan Mitchell sees the direction

whenever was essentially to utter the word avant-garde, to declare what was most important and forward-looking and what, in a sense, art had to be.

This is an oversimplification. But there is truth in it. A truth that became more true than the literal truth. Gertrude Stein, for instance, wanted to be in Paris because it was vital to be in Paris, there was a vitality for art and for thinking there in Paris, a vitality that a person wanted to get close to. The word "Paris" had a kind of magical power to it at that time, for certain sorts of people. This truth of the word "Paris" had become a kind of symbolic truth and thus even more true than it would be if it were literally true. The symbolic truth of Paris as a magical word that stands for art, the name for what is avant-garde and for what art must be, all of this was destroyed by the actual experience of World War II and by the seismic shift and reorientation of all things that that war initiated, and because of all this, it just so happened to happen that New York City, after the end of World War II, became the avant-garde, became the new name and the new magical incantation for what the artist seeks. And that was the very place and location where Joan Mitchell went, along with all the other painters and artists and poets and thinkers, as it became the very duty and job of being an artist to have a relationship with New York City—at least if you considered art to be something that has a history and a story and trajectories and that, in a sense, art has its own destiny, and it is the destiny of those who are artists to connect themselves with the greater destiny that is the history of

art itself, and so that was the place Joan Mitchell went. One can, indeed, have many qualms with this idea of art and destiny, and there is another history of art that would be the history of all the art created outside the trajectory of this self-defining destiny, and this might be as interesting a story as any other, but it was not Joan Mitchell's story.

Joan Mitchell understood the power of and pull of this sense of art and destiny, and that is why she ended up in New York City with all the others and why she pushed and pulled with Hans Hofmann and went through all the other rites of passage, as we might call them, that were a necessary part of connecting oneself to the destiny of art as it passed through the death of Paris and the birth of New York. Joan Mitchell understood all of this and then, in a strange reversal, she went back to the very place that had just died, allied herself, for reasons difficult to understand at first, with the very place that had just been superseded.

It was a perverse thing to do, is the point. The perversity of it should not be underestimated. Plenty of artists, it should be said, end up going away somewhere. Even Gertrude Stein and Alice B. Toklas spent a good deal of their time away from the center of things in Paris. A person needs a break. And sometimes you want to run as far away from the civilization that you think you are a part of and enter into another civilizational structure altogether, or at least pretend that you are doing such a thing. This is what Gauguin, for instance, did in taking off for Tahiti. Whatever one thinks of Gauguin

Joan Mitchell sees the direction

in Tahiti, or of Gauguin's horrifying journal of his life in Tahiti, *Noa Noa*, a book impossible to read without developing an almost pathological loathing for Paul Gauguin, a loathing so deep and disturbing that it almost becomes interesting again, whatever one thinks of Gauguin and his astounding proposition that authentic life, whatever that is, somehow exists in Tahiti, it is also clear, from one way of looking at it, that even Gauguin's loathsome journey to Tahiti was less perverse than Joan Mitchell's decision to go to Paris. Because going to Paris, you see, was going to the one place you couldn't go. You couldn't run away from one center of the avant-garde and the place that declares itself the destiny of art in its historical moment, you couldn't reject New York by going to the very place that just lost that very title, was just rejected as the location for the destiny of art just a few years previously. The stench of the dead avant-garde was still thick on the streets of Paris in the 1950s and 60s. The stench was all the more putrid for being the stench of the recently deceased. Going to Paris in the 1950s was like declaring that you never got the message, you hadn't received the cable, you never opened the letter, you hadn't read the news. It was to mark yourself as a naif chasing after the thing that already stopped being cool to anyone who knows what is cool. It was an act of utter perversion.

Unless, of course, unless this act of perversion was itself the point. And then it makes a kind of sense again. It has its own perverse double logic. Was Joan Mitchell, in short, somehow allying herself with a different story

of art and destiny in her decision to double back on the narrative of destiny, to turn against the thing that was supposed to be next, to deny that her art had anything to do at all with the trajectory of progress, if we can call it that, that drove the avant-garde from Paris to New York City? Was allying herself with death exactly the point? Was she allying herself, in a sense, with the losers of history as a kind of willful act?

It is said that after Jean-Paul Riopelle ran away with the dog walker, this dog walker who was, in fact, much more than a dog walker, but who was a young woman that had become very close to Joan Mitchell and also a lover of Joan Mitchell in some way hard exactly to define, a physical lover of Joan Mitchell for a time and also of Jean-Paul Riopelle, a young woman, therefore, who was involved in what can only be called a ménage-à-trois with Joan Mitchell and Jean-Paul Riopelle and who was, as the dog walker herself later claimed, far more enamored with Joan Mitchell than she ever was with the large-haired Jean-Paul Riopelle, this dog walker who became the cause and occasion of the final and definitive break between Joan Mitchell and Jean-Paul Riopelle was also therefore the unintentional cause of Joan Mitchell becoming somewhat obsessed, for a time, with the opera by Henry Purcell known as *Dido and Aeneas*.

Joan Mitchell's fascination with Purcell is, on the face of it, of course, about Joan Mitchell simply playing the spurned lover. She was playing Dido. Oh, poor, long-suffering Dido! Dido of Carthage. Aeneas has sailed to Carthage on his long journey that will eventually take

Joan Mitchell sees the direction

him to Italy and he has ended up in Carthage somehow. I don't actually remember why Aeneas is in Carthage at that point and I can't really bring myself to read the *Aeneid* again because there is something so oppressively ponderous about that epic poem and so embarrassing about Virgil, something so downright toadying and wretched about Virgil, and I often feel that one is either a Catullus person or a Virgil person, and that it is simply impossible and immoral to be both. One must choose. To be a Catullus person is to be almost violently opposed to Virgil, who wrote some very good poems it should probably be said when he wasn't writing wretched and embarrassing epic garbage, and there is nothing wrong with liking the *Georgics*, though, truth be told, I don't even personally like the *Georgics* very much and trying to plow through those lines is like a kind of punishment in that it is just words, just a bunch of flowery words piled one upon the other in a kind of poetry-as-piles-of-adjectives display that starts to make a person physically unwell after imbibing too much of it.

No, in the end I suppose I cannot abide with Virgil in any way, either with the openly repulsive epic work like that to be found in the downright repellent *Aeneid* nor even in the more seemingly palatable works like the *Georgics*, which are, once you scrape the pretty words away, completely empty, just a steam of words bubbling away in a cauldron of emptiness that, with complete lack of shame, pretends if you throw enough words at something you'll have finally grabbed hold of it. Virgil's poetry is actually tremendously aggressive in that

way, the way that he lobs huge volumes of words at the world and hopes that in this deluge of verbiage he will somehow have subdued that thing, the world, he'll have brought it to heel simply by having overwhelmed experience with the sheer number of words he was willing to wield in the effort to talk about his stupid cornfield or whatever. Was Virgil ever in complete misery at the sight of his cornfield, one wants to ask? Did he ever look out at his cornfield and realize that he simply had nothing to say about it at all? Did he ever fail to think of some insipid philosophical tidbit when contemplating his cornfield? Did he ever glance out at his cornfield and suddenly realize that, even after years of staring at his cornfield, he still has not even the faintest inkling of what it really is, that cornfield? Did he ever simply collapse in despair when contemplating his cornfield? Apparently not. Apparently, every time Virgil took a look out at his cornfield another stream of adjectives spewed forth, another deluge of second-rate thoughts on the already tired theme of man and nature, another stream of overwrought similes and metaphors and words words words words words words words. That, in short, is why everyone hates Virgil. And yes, dear reader, I am very aware of the thing about which you are currently wondering whether I'm aware.

However, Virgil did manage to create a pretty interesting character in the character of Dido. Probably despite himself he managed to tap into a number of interesting forces at play in history and art when he created his character of Dido. Because Dido gets yanked

Joan Mitchell sees the direction

around quite a bit. She gets tricked, basically, into falling in love with Aeneas, because how else could anyone fall in love with Aeneas, since Aeneas is deeply and profoundly an idiot, and so she is tricked by the gods, as it were, into falling in love with the idiot Aeneas and into having a nonetheless intensely pleasurable fuckfest with Aeneas in a cave somewhere near Carthage during a thunderous rainstorm, and the result of this romantic thunderstorm fuckfest is that the two are more or less glued to one another for a period of time, Aeneas and Dido, they are basically physically glued to one another as anyone who has engaged in that sort of intensely physical fuckfest knows well. The very idea of uncoupling is intolerable. This is the pinnacle of physical love. And it is not nothing. No, it is a serious thing. It is to the honor of the otherwise detestable Virgil that he included the thunderstorm-in-a-cave fuckfest in the *Aeneid* because he was being honest to the power of physical love in that passage of the *Aeneid*. The physical need to be with a person once you've experienced this kind of rainstorm fuckfest with them cannot be described. You've either had the fuckfest or you haven't. If you've ever had a fuckfest, then you know what was going on with Dido and Aeneas.

Joan Mitchell definitely had her fuckfest. She'd had the fuckfest with a number of people throughout her life, but we are safe, I would say, we are on very stable ground in assuming that she never had quite the fuckfest with any other human being that she had with the abundantly haired Jean-Paul Riopelle. The fact that

The Grand Valley

Jean-Paul Riopelle was an idiot like Aeneas was of no less a hindrance to Joan Mitchell than it was to Dido in *The Aeneid*. We do not always choose the fuckfest, it might be said. More often than not, the fuckfest chooses you, which is exactly what the ancient poems are always trying to tell us. The fuckfest cares nothing for the good sense or plans or intentions of anyone. There is a cave out there somewhere, somewhere on the outskirts of Carthage. Inside that cave, should you dare to approach it as the thunder pounds and the lighting strikes, should you have the audacity to go through the mouth of that cave, there will be fuckfest inside, a fuckfest waiting for you, a fuckfest that will mark your soul and change your life. The fuckfest in the cave does not care. It will have its way with you and you will not be in control of yourself, and you will not know what to do with yourself and you will find yourself beyond the bounds of yourself, the self that never had the bounds that you liked to pretend that it did in the first place. The fuckfest will show you this, and it will strip you bare. You will be powerless before the fuckfest.

Think of Heloise and her letter to Abelard. The first letter. An incredibly honest letter, one of the more devastatingly honest letters ever to have been written, probably. And what Heloise says is that she absolutely could not stop fucking Abelard not matter what. She just couldn't stop. They fucked in every corner they could find, every space that lent itself in any way to fucking they would rush into that space and use the space for desperate fucking every time they got the chance. It

was one of the legendary fuckfests of all time. Abelard, just to remind you of the story, was an eminent scholar and philosopher and logician and theologian and man-about-town of the time. He was a person who even wrote popular songs, a quite talented bard of sorts and someone who could wow the crowd in any pub of the day, the day being France in the middle of the twelfth century. And Heloise was a brilliant young student and scholar in her own right, and of a family with enough means that Abelard was hired to be her tutor and that is when the fucking began. That was where and when the intimacy was created. Because a mysterious intimacy must be created, a powerful intimacy must come into being anytime a true and genuine fuckfest is going to be let loose upon the world. Just think of the insane run toward fucking and obliteration that Jan Rubens, the father of the great painter Peter Paul Rubens, embarked upon with Anna of Saxony, the wife of William of Orange, an obsessive fuckfest that ruined both parties and a tale that one may have read in other chronicles, other books that get pulled into the mysteries of wanting and needing and being-toward-another.

Abelard and Heloise embarked upon their desperate affair, which was really just the unwinding of the logic of the unbounded need-for-another, the sense in which one can become unspooled by the power of nameless needing, a logic which took control of both of them and drove them forward despite, one might say, despite what they ever chose or decided on their own, and this dash into the self-obliterating logic of all-consuming

The Grand Valley

need ended with the uncle of Heloise, her guardian, putting an end to the affair fully and definitively by hiring some goons and directing those goons to get hold of the bard and world-class intellectual named Abelard and lop off the testicles of said bard-scholar. Sans testicles, Abelard retreated to a monastery. Heloise retreated to a nunnery. And it was from the nunnery that Heloise wrote her famous letter to Abelard.

In the letter, the recently nunnified Heloise says to Abelard that as far as she is concerned, as far as the whole matter seems to her with all the fucking and all the desperate need for one another and all the pain and then finally the shocking separation of Abelard the person from his testicles, after all of this and after the running off in shame and shock and the retreating to monasteries and nunneries—after all of this, Heloise says to Abelard that she finds herself in the position that if the very emperor of the world, if Augustus himself were to come forth and propose a glorious marriage to her, to Heloise, and thereby raising her above all other persons on earth, if this were to happen to her, to Heloise, that it would be more important to her, it would be to her honor and according to her deepest desire to throw that offer of marriage into the dirt in order to be Abelard's whore. That's what she says. That's what the nun in her nunnery says to Abelard and to the world. She says that I, Heloise, would prefer to be your whore than to be the most glorified person in the world.

And what does Heloise so desire in Abelard that she is willing to declare herself ever his whore? Mostly

Joan Mitchell sees the direction

it is the Little Abelard. Little Abelard is concerned with real life, whatever that means exactly, but we know it meant something to Heloise. This person, who unspooled the heart and the person of Heloise, this poet and philosopher who dissolved the boundaries of the being-who-she-was of Heloise, this person, says Heloise, this person she would have followed into the very fires of Hell. And what she doesn't fully realize, our Heloise, is that she really already had. The sheer dissolving of her being-who-she-was in the face of the poetry and bigness and therefore littleness that was within Abelard, and which he himself was not the originator of nor even the master, that one thing which he himself did not master mastered them both and turned them both into whores, if we can put it that way, turned them both into slaves of the fuckfest.

I've never actually done anything for love of God, Heloise wrote to Abelard. She didn't go to the nunnery to serve the God of the cloister. She went there because that was the next thing to do. That was the logic of the fuckfest. And that *was* God for Heloise. The real God. The God that can be found in the unboundedness of poetry and thinking that spirals into itself and eventually the unspooling of the fuckfest and the descent into Hell. That's what she said. Just read the goddamn letter. Heloise could give a crap about the official forms of worship. The only form of worship that ever made sense to her was the overwhelming abandonment of being-who-she-is and merging into just being-beyond-oneself that she experienced in the being-one-with-poetry-and-song-and-philosophy

and the fuckfest with Abelard. Was Abelard a Jean-Riopelle-level cad? Of course. There is nothing more abhorrent than Abelard in those letters. He's a coward, pure and simple. But not Heloise. Sure, she went to her nunnery. Fine, she says, I'll go to the nunnery. What do I care? But she does so without regrets for the poetry and philosophy and the fuckfest, and without any regret for the form of God that she encountered therein.

17. Another glimpse into history as a test. Another glimpse into the denials of the great losers. The way rarely taken: Dido, Carthage, the Suffering Servant.

AFTER A PERIOD of time glued to Dido and soul-deep in the fuckfest, Aeneas realizes that he has a bigger mission to fulfill. The gods remind him of this. That's to say, inside Aeneas there is a struggle. There is a war. What forces will Aeneas serve? To what must he pay obeisance? For he must pay obeisance to something. This is a must. What? You, modern person, you don't think you pay obeisance to anything? Really? You don't understand this concept of obeisance? It doesn't seem relevant to you, free person? Interesting. It must be hard for you to read the *Aeneid* then. You are looking for a hero fully in charge of destiny. But in Aeneas we find something less comforting. We find something more disturbing. We find an empty placeholder. We find a husk of a person buffeted about by forces far, far beyond his control. We find stories in which destiny and fate are almost completely in control.

The Grand Valley

And yet there are those tiny moments. Those tiny moments when the husk that is a person gets the chance to exert just one tiny bit of will, one minuscule helping of actual choice. And that choice, then, becomes immense. What will you do, Aeneas? What forces will you serve? In what form will you have your destiny? And Aeneas does choose. He sides with Jupiter over Juno, if we can put it that way. He sides with Rome over Carthage. He chooses the founding of Rome against Dido. He chooses the winning side. And Dido pines away as Aeneas sails off to make Rome possible. She throws herself down upon the sword that Aeneas left behind and extinguishes herself. And we feel disappointed in Dido. For who would throw life away for the idiot Aeneas? But that's not the point exactly. Even the execrable Virgil knew enough to understand that these choices, these moments where the husks that are people are put into a situation of choice must be accounted for. The *Aeneid* is, in essence, a tribute to the historical forces, the deep-seated historical processes and the near-infinite set of individual decisions that finally led to the establishment of the worldly triumph that is Rome. In this, the *Aeneid* is a not-entirely dishonest account of all the choices that must be thrown away, all the Carthages that must be destroyed, all the Didos that must be denied in order that Rome may be.

How we think about all this depends on how we think about Rome. Embedded, then, within the *Aeneid* are some lessons, more or less unintentional, about what it might look like if one zigged in the face of the

historical zag of Rome. Or, for that matter, when the historical avalanche points toward New York, what does it mean to head hellbent in the other direction, back to the dead zone of Paris, back to the veritable Carthage of the time? What does it mean to write the poems of Rome? What about the poems of Carthage? What would those poems be? What are the paintings of New York, the triumphant New York of the postwar era? And what, then, are the paintings that go in the opposite direction? What are the paintings that, finally, deny New York just as it claims its historical victory? What does it mean to go back and paint the paintings of Paris / Carthage in the time of New York / Rome? What does it mean to want to be Dido, to choose Dido, to affirm Dido? What does it mean to go looking for your Aeneas just so that the fuckfest might be initiated and so that you might become your own Carthage? What does it mean to choose loss? Why do it?

Over and over again, just after the magnificently-coiffed Jean-Paul Riopelle left Joan Mitchell for the last time, went off with the dog-walker as Joan Mitchell liked to put it, she listened to that opera, the opera *Dido and Aeneas* by Henry Purcell. She listened, presumably, to the famous aria known as "Dido's Lament." She was indulging, of course, in her role as the scorned woman, the spurned woman. She was being entirely and overwhelmingly dramatic. She was sinking to the floor in her misery and she was mouthing the words of Dido's Lament. But was she also doing something else? Was she also affirming something? Was there a little smile on

her face, a smile not unlike the knowing grin on the lips of our ridiculous Swiss doctor, the knowing and willful grimace that has joy in it?

We are all called to answer this question. What do you do, what will you do, how will you behave in the face of Rome? What is your answer? Do you serve Rome, or something else? Because there is only one way to oppose Rome. There is but one true rebuttal to Rome. It is with silence. It is with surrender. It is the opening up of one's arms, opening them far and wide and allowing oneself to be done away with. Will you serve the emperor or will you become, in your own way, whatever that way is, the suffering servant? Will you bow your head and take up your lot with the losers of history? Will you do what Dido did and what Joan Mitchell did? Will you deny Paris and Rome and side, in your own quiet way, with the suffering servant? That's the only question that can ever be worth anything. That is the hardest question to answer, because it must be answered with your entire life.

18. We get a little abstract and we make up a bunch of words and phrases in order to describe what Joan Mitchell was doing on the canvases she painted in 1964, a kind of *annus mirabilis* for Joan Mitchell in which she obliterated herself and therefore also became most herself.

BEFORE JOAN MITCHELL moved out to Monet's part of France, before Jean-Paul Riopelle ran off with the dog-walker and while she was still in the heyday of her greatest period of artistic ferment, around 1964, she painted a number of canvases that are mostly just centers. I love these paintings so much that I don't really want to talk about them.

To be a true lover of Joan Mitchell would be simply to look at these paintings and to be with these paintings, to spend time with these paintings and slowly to allow these paintings to make the divots in one's soul-space that they will eventually make. And then, just to shut the fuck up. That would be the purest thing to do.

The Grand Valley

But then a second thought comes. What about the fact that I am not pure? What about the necessary job of being the individuated person-thing that I am and that you are? What about Carl Gustav Jung smiling at us from across his idiotic clinician's desk and winking at us with the knowing wink? What about the fact that Joan Mitchell stabbed almost everyone she ever cared about in the back? She could turn on anyone in a second. She could betray anyone. Is being true to Joan Mitchell then being willing also to betray her in kind? To attempt to say more than she would ever have wanted anyone to attempt to say? And then also of course to fail. To look back at the empty words and realize that they say nothing, just as Joan Mitchell realized, again and again, that her canvases were nothing, that they achieved nothing at all.

The year 1964, anyway, was a good year. There's a work, *Untitled*, from that year that is a giant mass of green that takes up most of the canvas. And then there are all kinds of spongies and skoogies around the outside of the dark green center. Like looking into the mass of green stuff that is a spot of happening and then just not knowing what the hell to do with that mass of stuff that densifies itself and takes over the seeing that is a seeing into nothing, a seeing that goes beyond this centrifuge of green, or is pulled down into it and becomes a seeing that is beyond seeing. And then the outer scritchy scratch shows us how the density of green lets loose and gives way to something lighter and less dense. This is how the world is ordered, though it is ordered

We get a little abstract and we make up a bunch of words like that more in some places than in others. What I mean is that the world is always ordered in this way, but in some spots it seems to be more what it is than it is in other spots. Of course, that's not really possible, since the world is exactly what it is everywhere and at all times. That's true. But also, the world is more what it is in some places and at some times. These two facts sit uncomfortably alongside one another.

Joan Mitchell had a deep sense for the double and seemingly contradictory special / not-special nature of all experience, and I suppose this mix of density and scritchy scratchy at the edges was how the world was ordered on the western coast of Corsica and other spots around the Mediterranean in the early 1960s. Joan Mitchell was sailing around in the Mediterranean during loungy long days with friends and in the midst of a kind of ongoing fuckfest with Jean-Paul Riopelle, and it was all a matter of moving along freely and then hitting these punctuated densities of intense and dark green. It was landscapes that were suddenly concentrated here and there. You are floating through the ancient waters of the Mediterranean Sea and your own being is kind of floating there also in the mode of lounging and drinking and occasional screwing and seeing things hazily and then suddenly with moments of clarity and feeling certain moments with intense pangs of self-awareness that then hollow out into a not-entirely unpleasant emptiness, the emptiness of a fullness that hovers at your periphery. And Joan Mitchell was fascinated by these happenings of densification, by the focus and the

holding of these spots. The moments in time and the specific sites along the coasts of various islands in the Mediterranean are focused and holding, and they create a focus and a holding in the beings who come near to the focus and holding and are thereby, themselves, focused and held.

So the paintings that Joan Mitchell made are a focus and holding and also carry that focus and holding forward. They continue the process of being focused and held and of focusing and holding in those who experience the canvases. They make the chain of focus and holding longer and extended, and they allow that focus and holding to happen, now, wherever the paintings happen to be. The focus and holding and the release into scritchy scratch that exists in actual spots along the coast of Corsica are now also extended and real on the canvases that Joan Mitchell painted, these canvases no longer being tied directly to those spots in the Mediterranean in the summer of 1964 but now extended far beyond that in space and time and yet, at the same time, in a crucial way, always tied down and always connected directly to the focus and the holding that was right there at specific spots as Joan Mitchell was focused and held in her entire being as she experienced and, in a sense, was experienced by the spots of density along the coast of Corsica during one particular summer of her life.

The densities carry a sense of a holding and a density of being but also an obliteration. That's the other thing. There is fear at the heart of those dark masses

We get a little abstract and we make up a bunch of words that Joan Mitchell created and recreated many times on canvases in 1964. You get sucked into those dark centers and the palpitating something or other that is in there, the fear in these centers of swirling green surrounded by the scritching and the scratching at their outer boundaries, the dread that can be found in these inner places is also a seductive dread. There is something going on in there, some secret being tantalized at the edges.

Even *Chicago* gets this treatment. *Chicago* of 1964 is another dark blob, like the dark blob at the center of *Untitled* and at the center of *Girolata Triptych*, but this time the blob is filled up and modulated by all kinds of blue. Maybe the blue is the less organic version of the same thing that beats and throbs at the center of the Mediterranean blobs. *Chicago* is the colder version of the same thing she is trying to show in, say, *Calvi* also from 1964. The green / black mass in *Calvi* is situated a little more at the top and to the right portion of the canvas. This makes sense because when you are looking at Calvi, the town of Calvi in Corsica, you are probably looking at it from the side or from out in the water and you are always looking up a bit, at least if you've been sailing around on boats here and there in the Mediterranean Sea and feeling the emptiness of the horizon always out there at the edges of the sea, but also seeing that this beckoning horizon gives way to the looming presence of rock and seashore and vegetation and the presence of something that breaks the horizon as this or that island comes into view. The fort at the tip of Calvi is perched there on the rocks just above the sea. It is perched there and it just

draws you out there and extends you up a bit as it draws out to the tip of the mini-peninsula there and just raises you up a touch. And that's what the painting *Calvi* does. The painting doesn't show you the visual look of Calvi, not in any recognizable way. No one could pick out the town of Calvi just by looking at Joan Mitchell's painting called *Calvi*. But the scritching and the scratching that is the presence-being of Calvi as the town moves toward its density out at the tip—that's there on the canvas by Joan Mitchell. And the way the town takes you out and then just lifts you up into a density and a holding and a focus that comes to something extraordinary, actually, something wonderful and scary and true, just the way that the world can resolve itself into certain densities, and the way that the holding and focus is so stunningly and really and truly there.

Or sometimes Joan Mitchell painted an area that has nothing to do with human densifying. That's to say, she was interested in the way that towns and cities and places of human interaction have their densifying. But she was also aware that human densifying is not the only densifying. She liked how trees could get all groupy together, for instance. So maybe she'd paint a copse of trees. Those masses of bark and expansions of leaves can get hold of an area and make it coalesce into a density and make a focus and a holding happen. Those trees will sometimes get together and do that, yes they will. The trees somehow also can get it into their heads sometimes to stretch a landscape all out horizontally and to create the wideness of the world, to participate

We get a little abstract and we make up a bunch of words in the widening of the world. But other times the trees have a different idea and they get all densified. The trees, sometimes, are interested in the tightness and the compression of being that a certain amount of tree intensification and huddling about one another can bring to the space.

Or sometimes maybe it is just one tree. One tree can make a stand in the world. One tree can establish a spot of being. Not all trees can do this. Different trees have different characters. Some trees would just never have it in them to make a density no matter how hard they tried. Most trees just never try. Probably, it is too difficult. But other trees get it into themselves to make a density just of their one tree-ness, their single being. That's what Joan Mitchell is paying attention to and letting pass through her and onto the canvas in *First Cypress* from 1964 and also *Blue Tree* from that same glorious year.

The year 1964, it should be clear, is my favorite year of Joan Mitchell. There are other incredible years. But in 1964, in that *annus mirabilis*, the densities and the holdings and the focuses are shown on the canvases and are carried into the canvases and exist on those canvases now for as long as those canvases will exist. Those canvases are the existing and the re-existing of the densities that were in the world when Joan Mitchell—that specific combustible person—went through the world at that specific time and took into herself those things, the no-space and the nothing-zone that was her being in the world at that time, she vacated herself and let

The Grand Valley

the densities in and, at the same time, the densities that came in hit upon particularities that were Joan Mitchell and which are the mystery of the fact that a person, Joan Mitchell, was completely penetrable by the densities and focuses and holdings that were being offered to her along the coast of Corsica and in other places, and even as she took on those densities and focuses and holdings, she herself was also a space of density and focus and holding, a specific way of being in the world that was filled with its own porosity and resistance in the specific pattern that constituted Joan Mitchell instead of some other being-in-the-world.

She allowed herself to paint that, or she became the reality of what happens when that specific coming-to-be-a-set-of-densities and a kind of holding and a focus happens in the world in this or that place and then carries through into a being-in-the-world that is present for it. She became that. She was ready to be that and allowed herself to be that and this is what then happened through her onto the canvas.

19. The ongoing painterly descent of Joan Mitchell and then the unexpected appearance of Hugo von Hofmannsthal, Francis Bacon, and *The Lord Chandos Letter*. The secret that is held within the terrible dying of the rats.

JOAN MITCHELL COULD do that sometimes. She could become the perfect conduit for a focus and a holding and for a certain set of densities. She could pass that way of being on into paint. Partly she could pass it on because she was so disgusted with painting much of the time. Or she realized that it was a sort of absolute futility. She was drawn to the emptiness and obliteration that is at the heart, the scary dark heart, of the process of going into the empty vacuum of being a particular entity at a particular time and then trying to let art happen there. What's the point of doing this or of doing anything at all? One can have that thought. Surrendering to the scritchy scratchiness of being means hovering around the whirlpool of emptiness that is any existence. Existence that flitters up and then flitters away. The life

of all things as the life of the mayfly. The mayfly as the fundamental form of all existence.

Sometime in those years Joan Mitchell discovered the writings of Hugo von Hofmannsthal. This was a meeting of the minds, a meeting of souls perhaps that was always waiting to happen. For our purposes, there is really only one thing we need to know about Hugo von Hofmannsthal. We simply need to know that he wrote *The Lord Chandos Letter*. He wrote the Lord Chandos Letter, which is in itself an incredible thing to mention since the Lord Chandos Letter is, by definition, a thing that cannot be written, because it is about the fact that there is nothing to say. The deeper one gets into the heart of being and the less there is to say, the more hateful and odious it seems to try at all. To try for anything. Don't try, as another hopeless romantic once suggested on a tombstone.

What exactly is the Lord Chandos Letter, though? It's a thing that Hugo von Hofmannsthal wrote in 1902. I say a "thing" because it doesn't really have a category. I mean it is a piece of prose, I guess. It isn't really a letter, since von Hofmannsthal wrote it in the voice of someone else, a person called Lord Chandos, who is ostensibly writing a letter to Francis Bacon in 1603. That's the conceit of the thing, the strange thing that von Hofmannsthal wrote in 1902 pretending that he was someone else writing in 1603 and writing, moreover, not just to any person but to the First Viscount St. Alban, the person also known as Lord Verulam, the famous early expositor of what would later come to be known as the

The ongoing painterly descent of Joan Mitchell

scientific method, the nearly immortal and important person known most usually just as Francis Bacon, born in 1561 and dying in 1626. That's who von Hofmannsthal wrote a letter to in 1902, Francis Bacon having been dead for more than two hundred and fifty years, a problem which von Hofmannsthal fixes by pretending that he is writing a letter in 1603, the year in which Francis Bacon was knighted by James I.

What does Francis Bacon have to do with anything, I guess is the main question. Do we care about Francis Bacon? Does Francis Bacon matter for looking at the paintings of Joan Mitchell and for contemplating the dissolution of the relationship between Joan Mitchell and Jean-Paul Riopelle and for the distressing incident with the dog-walker? Distressing to Joan Mitchell, at least, though I suppose also distressing to Jean-Paul Riopelle and finally, as we know from her later comments on the matter, to the dog-walker, who only entered into the picture to make a few dollars walking a dog and ended up as the great perpetrator / victim of the final collapse of the extremely tumultuous sometimes terrifying and occasionally exhilarating fuckfest that was the encounter between Joan Mitchell and Jean-Paul Riopelle.

And now Francis Bacon—the Francis Bacon of the sixteenth and early seventeenth centuries, not the violent painter of the twentieth century—this, I guess we could say, this late Renaissance figure who wrote the famous, utopian (everyone always links the word "utopia" to it), and often-referenced book *New Atlantis* and tons

of other essays that people read and refer to and which became part of the longstanding canon of books you are supposed to read. How did Francis Bacon get mixed up in all of this? How did a person who, in every painting and in every etching and portrait I have seen of the man, is always wearing a neck ruff, how did this neck ruffian and writer of essays that can't go on for more than a few sentences without quoting Seneca or Cicero or someone like that, how did this person of classical reading and neck ruffs get tangled up with Joan Mitchell? The only answer is that von Hofmannsthal had something to say to Francis Bacon and so he said it through a made-up personage named Lord Chandos.

Certainly there is every reason *not to* express, *not to* express in words, or in song, *not to* express in dance or in paint. The true artist, according to Lord Chandos, is the artist who just stops. Because you're completely ruining it by trying to get it down. You're dishonoring it. You're just going to get it wrong and in getting it wrong you're going to throw yourself and everyone else into greater despair. Just live, live in whatever way you live. Shut up about it. Have the decency to shut up about it. And then, when it is time, go crawl into whatever corner into which you'll crawl and die there, as silently as you can. Be alive for a brief few moments and then have the decency to die without blathering on about it.

That is the true artist. Maybe.

Anyone who has stumbled into the scritchy scratchy realms wherein one's own being, one's own existence, begins to shuffle off, and the true

The ongoing painterly descent of Joan Mitchell

insubstantiality of it all wells up from the darkness, anyone who has wandered into this place, is well aware of its terrifying power. It is the source of truth and the obliteration of the need for truth at the very same time. It is the possibility of really getting to the one true core of all, of everything. And it is the recognition that there, at the true core of it all, is nothing to say. Joan Mitchell, like all artists who venture into these zones, who find themselves pulled into the regions of obliteration, who keep pushing down, down, further, perhaps, than they really should allow themselves to go, artists of this sort are always ashamed of themselves a good deal of the time.

Von Hofmannsthal, in the letter he wrote, the one that claims to have been written to Francis Bacon in 1603 but that was, in fact, written by none other than von Hofmannsthal in 1902, this letter, this nearly unreadable letter, unreadable because of how far down it goes into that place, into the depths of that zone, the zone from which Joan Mitchell herself dredged up the well-nigh superhuman strength it took to paint, this letter has an especially memorable section, so memorable that one immediately wants to forget that you've read it, wants to forget, but is unable to forget, and this should-be-forgotten-but-actually-unforgettable passage in the letter is about rats. It is about rats dying in a cellar after ingesting the poison that has been laid out for them. It is about Chandos / Hofmannsthal out riding his horse but, in fact, not being in the fields riding his horse, not really, not in the fields at all but in fact down there in

the cellar with the rats, feeling with every fiber of his being the thrashing and the panic and the rage and the seething and the screaming death of all those poisoned rats, the rats dying in agony and bodily contortion. The mother rat that dies in the midst of her own children, themselves thrown and buffeted by the tortures they experience within, but this mother rat no longer even concerned with the horrible deaths of her children, this mother rat herself turned toward the wall that cannot be penetrated and knowing that this wall is her final sight and turning up her teeth in a grimace and even maybe in a kind of ratty growl that sweeps out, somehow, from the cellar of death and makes its way, knowingly, out across the fields into the consciousness of Chandos / Hofmannsthal as he rides his horse out across the fields with the earth beneath the hooves of that horse and the sky up above.

It is not pity that Chandos / Hofmannsthal feels in the merging of his consciousness with the horror of the rats, nor regret, exactly, that he feels, and he writes in his letter that it is very important that his experience not be put into the category of pity. This is, perhaps, the crucial point to understand in the entirety of the letter. The death of the rats is not to be understood in moral categories. It is not to be understood at all. It is to be felt. It is something that washes over Chandos / Hofmannsthal and in washing over him brings him close, so very close, to the unutterable core of being as a being-in-the-world with the tremendous swirl of coming-into-being and passing-out-of-being and the ripping and tearing of

The ongoing painterly descent of Joan Mitchell

the fabric of being, the inherent beyond-reason forms of suffering, of simply going through it all that all beings must face simply in being beings and that there is beauty in all of this and joy, yes, and there is utter and terrifying emptiness in this coming and going, yes, and that all of this can be sensed and felt in everything, one can become a being who takes all of this in and through oneself and lets it all wash over and through and to do this, to become this kind of washed-over-and-through sort of being, the being of ultimate suffering, of flaming suffering, that this is where a certain kind of art leads and that when one is led there, led to that place, this place of suffering, that the attempt to say anything about it, to use words or paint, or anything else, that this seems suddenly the height of pointlessness, of absurdity, of hubris, and that the most honorable thing to do, at this furthest limit, at this far touching point of the absolute, the only reasonable thing to do is to drift into the silence that is the only true speaking there ever was anyway.

Except that, of course, in another delicious contradiction, the Lord Chandos letter does in fact exist. Hugo von Hofmannsthal did, in fact, write this letter that expresses the inexpressible. And sent it to Lord Francis Bacon, interestingly and of all people. He sent it to Francis Bacon, the ultimate talker and knower and expresser.

20. From the terrors of *The Lord Chandos Letter* to the obsessions of Monet and the repetitive nature of Impressionism at its essence. The fear and desire that drives Monet forward.

WHICH BRINGS US back to Monet. Funny that this would happen, since there would seem to be no one further from the sentiments Hugo von Hofmannsthal expresses in *The Lord Chandos Letter* than Monet. Monet, who painted so many thousands of paintings through such a long life. He painted and painted and painted until basically right up until the point of his death at the ripe age of eighty-six. He had not been in good health. He was dying of lung cancer and had more or less gone blind years before. And still he painted. Endlessly able to make work. Endlessly having something to say, something to show. Not at all caught in the Romantic trap, the self-negating trap in which expression itself becomes something of an embarrassment. Not for Monet. He was never embarrassed to paint.

Just look at all the water lily paintings that Monet made in his later years. I have read that he painted more

than two hundred and fifty of them. This was not a shy person. This was a person, this Monet who essentially never stopped talking on his canvases. He never shut up when it came to painting. He wasn't embarrassed in the way that the typical Romantic artist is embarrassed, hesitating at the very cusp of production, realizing that the most admirable gesture would have been silence.

But then again, on the other hand, just when you think of Monet as the very opposite of the Romantic artist, you start to become suspicious of all those water lily paintings, for instance. Why so many of them? The sheer number and volume becomes suspicious. Couldn't a hundred less have done the job? Why the incessant and obsessive return? Why the lack of trust in even, say, fifty or sixty paintings? Couldn't fifty or sixty paintings of water lilies end up saying sufficiently whatever Monet needed them to say? And even fifty or sixty seems quite a lot of water lily paintings.

But let's go ahead and give Monet that. Give him his sixty water lily paintings. Say what you need to say, Claude, with sixty paintings of water lilies, and that should very much close the book on the subject. But no, Monet keeps painting. And so isn't he, to some degree, isn't he destroying all the previous paintings with the relentless production of ever more water lilies? Doesn't the sheer profusion of water lilies start to seem like a deep distrust in his own capacity to capture what needs to be captured? Isn't each new painting denying, to some degree, the sufficiency of all the other ones he's just painted? You could, I suppose, see the matter as an

approach to painting that believes deeply in accumulation. If he somehow paints water lilies in every possible light, from every possible angle, at every possible time of day, from every possible point of view, then maybe the sheer accumulation of material will begin to say something definitive. I suppose there must be something like this impulse operating in Monet. He was also playing at this in his famous series of the Cathedral at Rouen. He painted the cathedral at all times of day in all kinds of different weather conditions. He was, after he became the painter that he'd become in the wake of Camille's death, given to overdoing it. He must have painted that cathedral more than thirty times.

Often, those Rouen Cathedral paintings are discussed as if Monet painted them out of his confidence. As if he had a plan. Wanted to prove a point. Look, here is one thing, the Rouen Cathedral. But look, the one thing is also a multitude of things. Look, you fool, it's the light, it is really the light. It was always the light. The Rouen Cathedral paintings are often put forward as a kind of philosophical treatise on the nature of substance, on what makes things what they are. And basically, everything is always changing because of light and atmosphere and whatnot. The implied philosophy of all Impressionists. Substance is actually accidents or something like that. Or, what you think is the most substantial, what you think makes things what they are is actually the least substantial and what is the least substantial is actually the thing that most makes things what they really are. I take the point. There is obviously

a philosophical thought similar to this underlying many of the painterly acts we call Impressionist.

But when you read the notes that Monet wrote to himself about those Rouen Cathedral paintings, you get a very different insight into the whole affair. Because, in fact, Monet was not feeling very confident at all. He didn't paint the damn cathedral thirty times because he had a giant and confidently held philosophical point to make. Some quasi- or more properly reverse-Aristotelian point about essence and accident. Essence is actually accidents and accidents are actually the true essence. Or whatever. Actually, he kept painting because he kept failing, or at least that was how it seemed to him. He kept seeing more and realizing that his previous attempts were missing something, that they had failed to grasp the real nature of this strange and grandiose visual spectacle that also is something more than a visual experience.

Monet went on to repeat this act of self-torture with other subjects. Once he'd taken on the challenge, he was addicted to it. He did the haystacks. Actually, I have read that they are not really haystacks, more like stacks of wheat. But whatever, those stacks of harvested stuff out in the fields. He painted those again and again. He did those first, actually, before the Rouen Cathedral. But there are only twenty-five or so of them. A veritable act of restraint when you get to the later series. And I think, but cannot prove, that with the haystacks or whatever—perhaps they are wheat or some other kind of stack—with the things like haystacks, he was more

or less having fun. He was just interested in how different they look in different situations, different seasons, different conditions. The particular look of that French haystack, or wheatstack, that just has a solid look to it. How could something so solid, that has such a clear and definitive I-am-this-thing visual and visceral statement to it, how could a thing like this also be so variable? Monet is fascinated by that. He is pushing at the various limits and possibilities of that hay-wheat-stack-thing, now in the fall, now in the winter (hey, look at the snow!), now in the evening light of summer (it glows!), now in the almost-disappearing light of the late evening (it is dark, but I'm still here!).

The way I look at it, Monet was transfixed with the possibilities he's discovered by painting that powerful, squat, sitting in the field with the little hat form of the stack—and why don't we just call it the stack, since that is the French word that Monet uses, *meules*, by the way, which says nothing about hay or wheat or anything else, just stacks—so, anyway, looking at those stacks out in the field with their oh-so-particular shape and bearing, he realizes that there is something deeply fascinating about how a whole series of paintings would take us through a kind of deep realization about how very different everything can be while still staying the same. That he can track this and show it. That we can all be taken on a kind of grand adventure of sameness and difference and the play between them. How many different ways can these stacks be the stacks that they are while

From the terrors of *The Lord Chandos Letter*

also being utterly and completely new and different and surprising?

And then, lo and behold, he realizes, Monet does, that there are other visual experiences based on strong rooted stuff out there in the world that have similar possibilities. The Rouen Cathedral, for instance. Also a squat thing that has its roots in the ground and a solidity but also, like the stacks with their charming little hats, the Rouen Cathedral is filled with all of those gothic nooks and crannies, those swoops and crevices and crags that take up the light and the shadows, and that move and throw out unexpected aspects. But already by the Rouen Cathedral, it is not so much fun for Monet anymore. The desperation in the project has already started to set in.

And then there are the poplars, many, many poplar trees. And the Venice paintings, which Monet despaired of and felt would only end in disaster. There are the Houses of Parliament paintings, plenty of those. Monet was in London then and seems to have lost his mind about mist. He kept with the mist theme for many if not most of the Charing Cross Bridge pictures.

And then finally Monet falls upon his water lilies. And it is pretty much water lilies from there on out with Monet. The water lilies get the final say. All the way to the last big project when he was basically blind, which, by the way, tends to make painting difficult, especially when your style of painting is so closely tied to the subtleties of visual experience. What does it mean to be blind and still paint?

The Grand Valley

Actually, that is the crucial question. If Monet is the painter of visual experience, of how things actually look to our eyes, if Monet is essentially just a giant and voracious eye, as Cézanne basically said and many others too, if Monet was the greatest and most deeply seeing eye of his time, how could it be that his final triumph, the last major statement about water lilies, was essentially a statement of a blind man, of someone who could not actually really see a damn thing anymore?

This is a problem, actually.

21. Where we explore the fact that Joan Mitchell, who not only went to live more or less in Monet's old house, also took on large painting projects that are not unlike what Monet took on in his serial paintings.

BEFORE WE TACKLE the large and embarrassing problem of Monet, the great eye, being also Monet the painter of blindness, it should be mentioned that Joan Mitchell, while in no way given to obsessive serial painting in the way of Monet, was, nevertheless, given to some serial painting in her own more restrained way. She liked to paint cypress trees, for instance. You could say, by the way, that cypresses were to Mitchell as poplars were to Monet. And this makes sense, when you think about it, because for Monet it was always basically and in the last instance Normandy, while for Mitchell it was always, basically, and in the last instance the Mediterranean. Even though she went and lived in Monet's Vétheuil, in Monet's Normandy and in the place where Monet had buried his wife Camille. Still, she was trained in her seeing and feeling and thus also in her painting by

the specific look and feel of the Mediterranean where the cypress grows.

Also like Monet, Mitchell liked to paint certain spots—for instance, our already discussed spot in Corsica—multiple times and with multiple approaches. And then of course there are the Grand Valley paintings, twenty-one paintings in total. So, there is a kind of Monet-like need to get serial on things in Joan Mitchell. Not to his degree, of course. Not with his special form of *idée fixe*. But still.

The story of the Grand Valley paintings is complicated but worth getting into a bit because of how surprising it is when you work it all out. What happened is that Joan Mitchell's sister died. We are up to 1982 at this point. Joan Mitchell's older sister Sally Perry had some kind of cancer, if I remember correctly, and she died. This was very upsetting to Joan Mitchell, who had a long and complicated relationship with her sister and who had all kinds of complex feelings, no doubt, about her sister and about all the members of her family, and about everything having to do with her rather upper-crusty upbringing and with all the difficulties of becoming Joan Mitchell in that milieu.

The summer Sally Perry died, a person named Gisèle Barreau came to stay with Joan Mitchell in Vétheuil to be a kind of assistant and companion of sorts, kind of like the dog-walker who eventually ran off with Jean-Paul Riopelle but with less disastrous results. Mitchell had met Barreau a few years before and was taken with Barreau and got excited about Barreau as

Where we explore the fact that Joan Mitchell

Mitchell could do about people, especially people who had some sort of intense art practice, which was the case with Barreau, who was a music composer and who, I suppose, still is because as far as I know this Barreau is still alive even as I pen these words.

It so happens that just as Joan Mitchell's big sister Sally Perry up and died, a cousin of Gisèle Barreau had up and died the year previous and Barreau was in a state of mourning still from the loss of that beloved cousin. It so turns out that as he was dying—and actually I think he was also dying of cancer, just like Monet's wife Camille all those years ago and just like Joan Mitchell's big sister Sally Perry and as Joan Mitchell would herself do in just a few years—this cousin of the composer and friend / assistant to Joan Mitchell, Gisèle Barreau, this unnamed cousin who Joan Mitchell never actually met, this cousin of Gisèle Barreau told Gisèle Barreau, just as he was in the process of dying, that he would like to see the Grand Valley just one last time if he could before he died. But, actually, he couldn't. That's because he died. Instead of seeing the Grand Valley one more time, he died instead. And that was that.

But what the heck is the Grand Valley? Well, it turns out that the Grand Valley is a place where the two cousins—Gisèle Barreau and the unnamed cousin who was dying of cancer—used to play together when they were little. I'm not actually clear on whether it was a real place or not. Perhaps it was just a garden in the yard where they grew up that they called the Grand Valley. Or maybe it was an actual grand valley the people in

The Grand Valley

that area called "The Grand Valley," and the two cousins had wonderful memories of this beautiful valley and the delights of childhood, running around in the valley and doing the imaginative and wonderful things that French children would have been doing in those times. Whatever the case, the dying cousin of Gisèle Barreau, as he was in the final stages of I think probably cancer—anyway, it fits my story better if it was cancer, so let's say it was cancer—this youngish person dying of a horrible case of cancer, probably stomach cancer in the very same spot that got Gertrude Stein, I wouldn't be surprised—anyway, this young person died while still wishing, one last time, to see this magical place, La Grande Vallée.

This story had a large impact on Joan Mitchell, and she decided that she would paint this Grand Valley. And that is what she did. She did it in twenty-one absolutely huge canvases. She really threw everything into the painting of the Grand Valley. Grieving the death of her big sister Sally Perry, and deeply moved by the story told to her by Gisèle Barreau, Joan Mitchell took on a Monet-esque mega-serial project of painting.

22. A little dive into the lives of children and how they experience special places and then how that experience might be transferred into a specific style of painting, a specific style of painting that was of specific interest to Joan Mitchell.

THE OBVIOUS THING to notice here is that Joan Mitchell had never been to the Grand Valley and therefore had no idea what the Grand Valley looked like and, in fact, I'm not sure if it was a real place or more like a childhood fantasy. Either way, all she had, all Joan Mitchell had, was a brief story about a childhood memory told to her by another person, in this case told to her by the woman named Gisèle Barreau whose cousin had died not long before Joan Mitchell's older sister had died. Anyway, Joan Mitchell got going on the canvases and ended up painting twenty-one, some of them more like double or triple canvases, and these canvases all told the story of this magical childhood place frequented by Gisèle Barreau and her later-to-die-before-his-time

The Grand Valley

cousin. There's no point in painstakingly describing the canvases Joan Mitchell painted and named *The Grand Valley* series, or really just *The Big Valley*, since there's no need to go so far as to translate the French word *grande* with the English word grand. It's too grand, probably. You could very well translate it as The Grand Valley, by the way, but there is no necessary reason to do so, since the French word *grande* can just mean big in the simplest way, it can be both big and grand, as it were, and I, personally, like the way that calling it "The Big Valley" sounds in a way like something a couple of children would say—"We're going to the big valley!" they might say, yelling it to the adults in the house as they run out giggling into the yard and to their secret place.

That's the sort of place, The Big Valley, that Joan Mitchell took to painting in her massive series from 1983. We can't describe all the paintings. Many of them are quite different actually. Some have more of a vertical feel and some of them are horizontal. Many of them have smeary areas where color gets all muddled up, and others are more precise, more distinct. Many of the paintings include the deepest blue you could ever imagine. Just imagine the deepest blue you can imagine and then you'll be correct that that's what's on the canvas. And the blue goes onto the canvas with big broad brushstrokes that move across the canvas with one or two or three up-and-down motions. Sometimes the areas of blue upsies and downsies give the impression of water but I'm not sure about that. It doesn't matter. More than anything, the blue gives the sense of something deep

A little dive into the lives of children

and somewhat hidden. That's the most important part, I would say. You can see green swizzles moving amongst the blue in some of the paintings and there is a quite definitive yellow much of the time as well, though not always. The yellow tells us that this place, this big valley, is a place with hidden excitement, an excitement that just jumps right out from the blue. You have to go into the blue, you have to approach the blue and give yourself over to the blue, and when you've done that, the yellow congratulates you, it gives you a kiss. In one version of the big valley there's a bunch of orange hiding just behind the blue. It is kind of funny, even, the way the orange is hiding there just behind the blue, you can see it there plain enough, like when a child just stands behind a lamp or something and thinks she's very hidden and everyone else pretends she is hidden too, because she has her hands over her eyes and she is delighted by her complete hiddenness, when actually she is just standing behind a lamp and everyone can see her, her knee with the one scrape on it from running around in the bushes of the big, grand valley and the little red marks on her elbows. That's the way the orange is hiding just behind the blue in one of the big valley paintings, hiding like a child and delighted by that fact.

These are the Grand Valley paintings that Joan Mitchell painted in 1983 after hearing the sad story about the dead cousin, that's what they are about. They're about something that children know when they go off to places like the big valley. Children do indeed know something when they go off to those places. They know

The Grand Valley

that they are going somewhere good. It might have scary stuff in it but the place is good, it is a place where you want to go, because it is full of more than itself, bursting with the content that cannot be described, but the content is more than it could possibly be, that much is clear, and also it is clear that it doesn't need to be explained because there it is, and the children describe it to one another again and again and keep changing it every time they do so. The big valley has this in it, the children might say, and then they change their minds. No, it has this in it, and also this. And then they think about it more and add some more stuff. And then the next day they forget a few of the things that they said were happening or are possible in the big valley and make up yet another new element. Stuff is always happening and always coming out of the big valley, deeply unexpected stuff, surprising stuff. But sometimes it is also very simple. Like, there's a big yellow flower in the big valley. Or, there's a big water in the big valley or a little orange happening in the big valley.

How do you paint that? How do you paint a place that exists partly as the possibility of another existence? How do you paint the mercurial shift of minds that are still willing to slide between what's wanted and what's seen and what's imagined at the edges of what memory gave? I don't know how you paint that, I don't know where you have to go in order to be able to make that happen on a canvas. But I do know what it looks like when it's done. It looks like what Joan Mitchell did in the series that she called *La Grande Vallée*. And it is

A little dive into the lives of children

clear that she had to paint these paintings in a forgotten place and that she had to kill off a few other versions of herself in order to enter that place, to have gotten to the little town in France by way of Hades, so to speak, and through the twists and turns that landed Joan Mitchell on the wrong side of history and on the losing side of life. That was where she could encounter the big valley, whatever it was, a place of nonexistence that she was able to see in blues and yellows and orange and swizzles of whatever colors need to be there when you're in the big valley.

23. Why was Monet so obsessed with water lilies? Why did he paint the same subject matter over and over? What happened in those final paintings where the water lilies seem to become unmoored from any anchor in visual reality?

I ENJOY KNOWING that Monet, like Mitchell, was also extremely violent with his paintings. He would punch them and kick them sometimes. He would get mad at the weather and how mercurial it can be, and then he would get mad at his paintings of the weather and just kick right through a painting. But why did he care so much? If he was so interested in the changing and ephemeral nature of that which we think is solid, then he should have loved the mercurial nature of the weather. But he very much did not. The wind would blow his canvases off their easels, and he would fly into a rage. He would throw all his brushes and his paints into the river. He would slash at the stupid and recalcitrant canvases with knives and whatever other sharp object might be around. He would curse and stomp about. He would behave badly to the people around him. He

would go on pointless tirades and blame people for random shit. He was nowhere near the violent drunk that Mitchell was, but he was not fun to be around much of the time, especially when he was painting or in the process of trying to work something painterly out in his mind.

They have been compared, the two of them, Claude Monet and Joan Mitchell. I'm hardly the first to make the comparison. How could the comparison not be made? Joan Mitchell basically went and lived in Monet's house, for god's sake, more or less. And then there is the issue of those last water lily paintings that Monet made, his final statement, the *Grandes Decorations*, the ones that they installed at L'Orangerie Museum in Paris and that blew everyone's mind eventually, though not at first, but eventually blew everyone's mind with how much they seem to make a leap from everything he'd been doing up to then, everything that still held some hard anchor in visual experience, and somehow those last water lily paintings move away and past the territory of visual experience and into something else, something people have always wanted to call genuine abstraction, though what exactly is that?

Maybe Monet was never quite so wedded to the so-called truth of visual experience, the ephemeral and weather-dependent so-called truth of immediate visual experience in all of its mercurial and accidental variety, the truth that never stays put and transforms itself every few minutes and that forced Monet to sometimes work on dozens of canvases all at once, to be surrounded by

dozens of canvases and to be dabbing at one here and another one there, and to be madly dashing around from canvas to canvas in order to capture something so unstable as to make the project of capturing this infinite variability something of a quixotic enterprise. Why do it at all? Why tell us what we already know, which is that the weather changes and the light changes and the mood changes and the quality of the day changes second by second? We have that experience every day. Why have it a second time on a series of canvases?

But maybe, actually, Monet was not interested so much in recording this fact, in documenting the shifting, undulating, passing, returning, escaping, sliding, dissolving, reconstituting nature of sensual experience. Maybe he wasn't as interested in that as people often think. He was interested in that, of course. You don't paint in the way Monet painted and you don't paint the kinds of things that Monet painted if you are not interested in that.

But maybe there was something else Monet was trying to show. There is something that hovers just under the surface of all these passing manifestations of the way that things are and the way that things keep changing the exact contours of the way that they are. Saying that there is "something" under the surface is not quite right, of course. There is no surface and there is no under. There is just the wheat stack, or the tree, or the cathedral. That's the whole point. Everything is wholly what it is in the moment that it is. And then, in the next moment, is another version of itself. There is

Why was Monet so obsessed with water lilies?

nothing more and nothing less to it. Cathedral. Wheat stack. Poplar tree. Bridge. Parliament building.

What else is there to say, what else to show? Nothing, of course.

But it has often been noted that at a certain point in painting his beloved water lilies Monet started to erase the horizon line. He was always interested in those reflections of the flowers and trees and whatnot in the water. The reflection of the water, the sense that you can see beneath the water and the surface of the water at the same time. This tantalized him. He wanted to be able to paint both things at once, the seeing through the water and the seeing the surface of the water. Because both things are real. We see the water and we have a sense of the surface, a surface is created in the water. And we see through the water, we can penetrate the water with our vision. And we also see the things that are reflected on the water. We are seeing the trees and the flowers and the actual water lilies that are on the surface of the water, and we are seeing the water itself, and we are seeing that which is beneath the water.

It is quite confusing actually and really should drive us mad. There are too many kinds of surfaces to try to sort out. Somehow we do it, though. And Monet wanted to show that, the intermingling of all these surfaces and the water showing other things and also showing what is in it, or underneath it, and also what it itself is. The water shows itself and shows everything else in showing itself. Monet wanted to paint that, didn't he? And to paint that he had to make sure that we would get

lost in all those doublings and enfoldings of seeing and reflecting and showing and hiding. So in some paintings he started to get rid of the horizon line so that the painting becomes extremely vertiginous. You're not sure, in looking at those water lily paintings, just which way is up and which down. Am I looking at the reflections of the trees and flowers in the water or the things directly? And where is the water exactly? Where does it end and the area above the water begin? Monet takes away any anchors in visual experience we might have used to orient ourselves. We have to go into the mad swirl of reflections and surface and not-surface and depth, or maybe not the depth at all but what is above the depths. You can't be sure.

The interesting point to consider here is that the not-being-sure is, in fact, the whole point. The not-being-sure is exactly where you are meant to end up, when Monet is painting water lilies, at least toward the end of his career painting water lilies. This is what happens when you spend all your time wandering around a garden and pond and staring intently at that garden and pond in order to reproduce some sense of that garden and pond on any number of canvases, hundreds of canvases, actually, canvas after canvas after canvas, so many of which you end up destroying or throwing into the fire or smashing to pieces precisely because they just don't do it quite right. Not that they don't, those destroyed and not-quite-right canvases, not that they are wrong because they aren't true to the actual visual effect of whatever moment Monet was trying to capture, but

Why was Monet so obsessed with water lilies?

because there is no specific visual effect, no visual thing-that-is-there that Monet was trying to capture. That is the startling realization a person can have looking at those water lily paintings, especially the paintings Monet made toward the last decade or so of his life, and especially when it comes to the paintings Monet created for his Big Decorations, as it were, the *Grandes Decorations*, the ones that they installed at L'Orangerie Museum. This isn't about the ephemerality of visual experience anymore, it is not about the way that objects, be they poplar trees or haystacks or wheatstacks or cathedrals or anything else, are both somehow stable objects through time but also so changing and transformative that the experience of being with them almost completely and utterly transforms them according to the vagaries of time of day and weather and atmospheric situation and anything else. No.

The thing about water lilies, you see, the amazing and troubling and wonderful thing about water lilies is that in their essence, in their deepest visual truth, they are just a smudge on the surface. But the surface of what? The surface of the water, which isn't really much of a surface in the first place. But also it is. The water lilies make that clear. Look, the lily sits right there atop the surface of the water. But that surface is also completely permeable. And also completely opaque at times, a mirror. It is a surface that marks a boundary between the above-the-water and the below-the-water but that very boundary is one that is simultaneously pierced and not-pierced while you are seeing it. Also physically, when

you think about it. The water lily, the lily pad, the thing that is the actual plant, it is both in the water and not in the water. It is above and below. It is on the water side and it is on the air side. It is, you could almost say, a reflection of itself sitting there in the water.

In the big decoration paintings, Monet lets all of that merge into one giant self-penetrating and interconnected just-there-it-is-ness of surface and depth and mirror and reflection and flipping perspectives of up and down and inside and outside and seeing-through and not-seeing-through and all of that, he puts it all there on the canvas so that at a certain point you have to give up on orienting yourself and sorting out exactly what surface is the real surface and what perspective is the grounding one, and you have to just let yourself go into the grand and gyrating and flipping-over-itself multiplicity of it all. You have to let yourself go. You have to let your self go. You have to not be the self that would decide. You have to stop deciding about any of it. You have to go into the canvas and stop fighting. You must—isn't this what those huge, long canvases at L'Orangerie are asking of us?—you must surrender to all those surfaces and reflections and layers of inside and outside and finally just to accept them all at once. Which is impossible. It violates something crucial to our normal sense of what holds an experience and a being-a-self together.

But Monet doesn't care. The water lilies don't care. Or they do care. They care in that they want something else to happen. Because, of course, the reality hidden

Why was Monet so obsessed with water lilies?

in the multiplying shifting surfaces of the world of the water lilies is true. Monet wasn't making it up. It is real. And you can become that reality if you let it happen. That's no doubt why Monet was such a bastard about those canvases and why he was so stubborn about the big oval rooms and the design and the architecture and all that. Monet was a complete son-of-a-bitch to everyone involved in the whole process of his gift to the French people, the French government and, really, his gift to the world, to the universe. He said: I want to give these last paintings as a gift to the French government and they can be shown in this old building that must be repurposed in order to accommodate them, and so the building that eventually become L'Orangerie was fitted out to his specifications, and the nightmarish job of trying to meet the needs of an extremely old and cranky painter fell to any number of people, and it was guaranteed to be a difficult and infinitely frustrating affair because Monet knew very well that he was asking for something nearly impossible.

He was asking to create an artwork that would reveal a truth: it would be a revelation. And this revelation would be the activity of looking at a series of paintings that rob you of your normal skills of looking, rob you of your ability to be the looking-thing that you think you are, and instead to throw you around and spin you on your own axis and smear and warp your sense of what the looking is looking at precisely until something else happens until eventually, with enough time spent really being in those rooms, you stop being the separate thing

The Grand Valley

looking at the other thing and you start just to become the whole of it. You start to be the whole tangled up inter-gnarled mess of it all. You finally get it just by more or less being it.

24. The unique way that space and distance operates in the special places where children go. The big valley is a place you can't go to. You are either in it or you aren't. There's a way to paint that, it turns out.

WHEN JOAN MITCHELL painted her big valley paintings, she did so with absolutely no concern for establishing what we're looking at. That was easy for her because she had no idea what she was looking at. She wasn't looking at anything. She was thinking about a story about a place that two children made up and created together, and that one of the children, who was later dying of cancer, said he wanted to go back to at the end of his life. His dying wish.

You are not looking "at" something in any of Joan Mitchell's big valley paintings because there is no "there" for you to be in as the viewer, and there is no specific "at" for you to be looking toward. You're in. That's closer to the truth of it. They are paintings that put you inside a place looking around. But you're not really looking around so much either because the

The Grand Valley

sense of around is hard to establish. You are too far in. That's what Joan Mitchell seems to have wanted to do with those paintings, to put you so far in so fast that you don't even ask any questions. You are just within the experience. These are paintings that evoke a heck of a lot of foliage. If you like foliage, these are the paintings for you. Foliage in various layers of density. Sometimes, the lighter foliage pops a bit to the fore and you get a sense of depth. The foliage recedes infinitely. And sometimes the lighter foliage feels like it is back behind some layers of denser foliage at the front. You could get to it but you don't know how. You just know that there are delights to be had if you could penetrate the layers of deeper darker stuff up at the front.

That's what secret places are like, after all, especially for children. You are fully inside and surrounded. The place feels mysterious and warm at the same time. A secret place. A special place. That's what those kinds of places are like. And then a shimmer of yellow here and a blast of orange there. Joan Mitchell really figured out a way to use up the whole canvas in these paintings, in the way she had resisted with all of her paintings in the 1960s, pretty much. But she used the whole canvas in the big valley paintings for her own reasons, not to please the New York abstract painters of old or some memory of what Clement Greenberg told everyone you were supposed to do and certainly not to please the bastard who ran off with the dog-walker. No. She used the whole canvas because it was necessary to make the big valley. In the big valley there is no emptiness and there is

The unique way that space and distance operates

no outside. In the big valley there is no looking-at standing over against the what's-being-looked-at. It has been erased, that distance. No distance allowed. Children do not have distance when they enter the big valley. They become the big valley and the big valley becomes them.

So, Joan Mitchell took all the distance out. That's what those paintings are about. Complete being-in. And the messy overwhelmingness of foliage. Because that is what happens when you go into a place with wild and unruly foliage. It breaks down the sense of clear perspective and chops up all the visual throughlines. That's why places of dense foliage can be scary sometimes. You lose your bearings. You lose your orientation. But also, there is something wonderful about going into the place of super-dense foliage and finding a spot where one can settle down in the little nook here or the tiny refuge there and feel enveloped in that space even though it is impossible to get a vantage point or a visual leverage point in space. You have to surrender any greater sense of orientation and just settle down into your nook. Be completely within it.

25. Joan Mitchell had a relationship with previous painters and she acknowledges this. But she was never happy being compared to Monet. And she was never happy with what anyone said about her paintings. She was not happy with theories about art. She was not happy. She preferred to say no.

IT SHOULD BE said that Joan Mitchell never liked being compared to Monet. She preferred to be compared to Cézanne. When she talked about painters she really liked, she would often talk about Franz Kline, at least when people asked her about the days of the AbEx painters in New York City, and she would also talk about Willem de Kooning. Buying the property in France in Monet's old town, with the old house where Monet used to paint, was therefore probably a terrible idea. Or, at least, it pigeon-holed Joan Mitchell in a way that left her feeling annoyed most of the time. It is also probably the case that she didn't like the way people talked about Monet's paintings, especially toward

Joan Mitchell had a relationship with previous painters the end of her life when there was often the lingering sense that Monet was a decorative painter, and that he worked with pretty splashes of color, which was also of course the dismissive language that many critics used, especially American critics, when referring to the work of Joan Mitchell, the work that had come to be associated with something in the French lineage that seemed suspicious and that was holding on to a prettiness and a femininity and a decoration that lingers amongst the Impressionist painters, as such associations were thought to have been finally and definitely cast off by the robust and manly New York painters who had finally wrested abstract painting from the clutches of the always somewhat suspicious French.

Joan Mitchell was sensitive to those accusations and tired of having to defend herself from those accusations and would usually make a slyly sarcastic comment or otherwise try to avoid those types of conversations, but they always bothered her and she rankled, often, at being put in the historical trajectory of Monet, because from the standpoint of the world of art and the world of painting in the era in which she lived and became a painter, it could only be a way of diminishing her.

So it is funny, and typically self-defeating and almost unbelievable, that Joan Mitchell bought that house, that she settled into the place that was often called La Tour and that she lived the final decades of her life more or less hiding out in the tiny town of Vétheuil where Monet lived for that period of time, the place where and the time when Camille died. Jean-Paul

Riopelle had lived out his usefulness to her at that point. The paint-slathering beast had gotten her to France and helped ensconce her in the old house in the old town once inhabited by Monet. His work was done. He ran off with the dog-walker, as Joan Mitchell always described the end of their relationship until her dying day, and that was that. She was left to herself and her occasional visitors, and to the various trees and the winding course of the Seine, which oxbows at Vétheuil and creates a number of stunning vistas that Joan Mitchell could look at and think about and work with as memories as she moped about her property in Vétheuil, often deeply depressed, and then sometimes painting paintings like the ones that treat of the big valley or other canvases full of color and completely enveloping and hard to say anything about because they are all consuming.

It is easy to suspect that the infamous Big Joan never quite understood why Little Joan wanted and needed to be in the mostly-lost-to-history and dying town of Vétheuil. Big Joan rankled at all the talk of Monet and Big Joan said whatever Big Joan needed to say in order to throw people off the scent.

In the film about Joan Mitchell the abstract painter, the film in which Joan Mitchell spends an hour or so more or less trying to avoid saying things about her painting as much as possible, at one point in that film, she is talking to the critic Yves Michaud, who has come to visit her at La Tour and who was in the process of writing about her work. Michaud is trying to get Joan Mitchell to be more specific about her paintings, and

Joan Mitchell had a relationship with previous painters she responds by being less specific, and at one point she simply says that you have to learn to see. And then she says, as an example, that you might be looking at a lemon or something on a table (I think she names another fruit but I forget what the fruit is), and she says that if you are a painter and you look at that fruit, the lemon or whatever on the table, and you are really looking at it, then you will begin to understand something, not something you can then translate into words, but understanding nonetheless. And you will understand the lemon or whatever, because Joan Mitchell did indeed name another fruit, or another object at least, but wherever it is, the lemon and the mystery object will begin to make a kind of sense that is similar, as Joan Mitchell describes it, to what happens to you when you really listen to a chord in music and you can hear the chord, the totality of the chord, and you can also hear the individual notes that make up that chord.

Anyway, Michaud keeps talking to Joan Mitchell in the clips from the film and he keeps asking her questions. He keeps asking, did you paint this to add more depth, did you put the white over in this spot here to erase something in the painting. He keeps asking questions like that. They aren't stupid questions, it should be said. They are perceptive questions. But Joan Mitchell just keeps saying no. Or she says I don't know. Or she doesn't know why she does anything that she does. She is being gentle (for her) on the one hand because she obviously likes this guy Yves Michaud and because he obviously looks deeply at her paintings and thinks

about them very hard. But she always says no. Whatever he says, she says no in one way or another. No. He is trying to think about her paintings in a certain way and she is trying not to think about her paintings in that way. So she says no. No. No. No. No. No. No.

At one point Michaud says about a specific painting that the white in it reminds him of de Kooning's whites. "I don't think that has anything to do with the white of de Kooning," she says, "poor man." Michaud and Joan Mitchell keep talking about white for a little longer. Then she says, "Well, it doesn't have to do with Moby Dick, okay?" She's starting to get mad. The combustible is starting to combust.

The camera cuts to a scene of Joan Mitchell sitting in an art gallery. "He knows I don't have a theory of why I paint or anything." She is presumably talking about Yves Michaud, but she could be talking about anyone. The camera cuts to another scene with just Yves Michaud. He is sitting just at the cusp, the entrance of what looks to be maybe a Renaissance courtyard, and he is alone. Joan Mitchell is not there. Michaud elaborates a few more theories about Joan Mitchell's paintings. She does not get to respond. But we hear her saying it anyway. We hear her, in our minds, saying:

No, no,

Joan Mitchell had a relationship with previous painters

no, no.

26. Joan Mitchell and the serpent.

AT THE END OF the movie *Joan Mitchell: Portrait of an Abstract Painter*, we see a very old and frail Joan Mitchell walking around a gallery with many of her paintings hung in the gallery. She is, I think, in the last year of her life. The film was released, anyway, in 1992, and much of the footage was taken in the final weeks and months of Joan Mitchell's life. She died in 1992 of advanced lung cancer, just like her sister had died of cancer and Monet's wife Camille and Gisèle Barreau's cousin, the cousin who had played in the big valley as a child, and then there is Gertrude Stein also dying of her stomach cancer in France and leaving poor Alice B. Toklas to her lonely fate. Not that cancer is a particularly rare disease or an unusual way to die. But I think there is something about cancer, especially the way it was experienced in those days, where it packed a special kind of kick, since medical science was well able to diagnose your cancer, to tell you that you had cancer, to give you perfect awareness of the fact that you had cancer, that the cancer had advanced to this or that stage and that you had, effectively, this many years or months or days to live, but that you could not do very much about it. Cancer

in those days, and often in these days too, of course, but to a lesser degree, was very much a death sentence very much of the time. To be told that you had cancer, especially a cancer of any advanced degree, was in effect to be told that you are going to die and relatively soon.

To have cancer in the way that Joan Mitchell had cancer and that other people in this story had cancer is to confront finitude with the kind of clarity that one doesn't get to face in other situations of living and dying. In other scenarios, a certain pretending can go on to the very end. Isn't that the dream of many? To drift off and die in one's sleep never having known that death was at the door? But then again, what does it mean not to know in this case. Because everyone knows. Deep down, everyone has confronted at least once the true and massive reality that life is living-toward-death, that one is a dying thing, that one's consciousness will be extinguished, that life is in fact a quite brief and strange thing that hurls ineluctably toward a finality that is difficult to comprehend, that cannot really be comprehended, that can, in those moments where one lets it, be so bafflingly shockingly incomprehensible that one's entire being is shaken. And to have cancer in the way that Joan Mitchell had cancer is to have the last flimsy illusion that the rule of death does not apply to you pulled away. To stand at the cusp of the abyss and to know that it is real.

So, a dying Joan Mitchell, in the film about Joan Mitchell the abstract painter by Marion Cajori, the film that shows Joan Mitchell in her absolute unwillingness

to reveal anything about what her paintings might mean or why she makes them, in this film of stubborn intransigence, a soon-to-be-dead Joan Mitchell, holding her cane, one of those metal and plastic canes that you get at the hospital that wraps around the forearm for greater stability and which Joan Mitchell surely received at one of her hospital stays as her life was in the process of ending, Joan Mitchell mentions that she killed a snake with the cane in her hands. She tells a story of a viper.

The way Joan Mitchell tells it, she was sitting out in the garden at La Tour in front of her studio and she was with her two dogs, I think that is what she says, she was there with her two German Shepherds, Marion and Madeleine, and they were having a grand old time and the birds were there, as she puts it, and the birds were also having a lovely time and everything was quite idyllic. The weeds were beautiful. It was all, "this moment, we exist…" Joan Mitchell's voice trails off a bit here. Then she says that her foot felt a bit heavy. That's how she describes it. A heaviness in the foot. There was a viper on her foot. Sound asleep. Perfectly happy. A content, sleeping viper. Joan Mitchell pauses for a few moments in her story. "You see, I was part of nature," she finally says. She was a part of nature and so the viper just sits on her, this part of nature.

But then she decided she better do something about the viper. Because a viper is still a viper. And then the viper woke up, I guess. Joan Mitchell doesn't say this explicitly in her telling of the story, but it is implied. The viper woke up and looked over at Marion, who Joan

Joan Mitchell and the serpent

Mitchell describes as "her passion." And when the viper looked over at Marion, Joan Mitchell took the piece of straw or whatever it was out of her mouth, she doesn't say exactly what was in her mouth, but she pulled it out, whatever it was, and she thought that she had to kill it, the viper. And she did.

"I don't know what that has to do with painting," Joan Mitchell says to whomever is behind the camera, presumably Marion Cajori, and then Joan Mitchell mumbles something else that is hard to understand and then she says, "You figure that out."

27. Carl Jung and the serpent.

LATE IN CARL JUNG'S crazy journeys into madness or into a visionary landscape or into dreams or into another version of reality or into the true reality or whatever and wherever it was that Carl Jung went, whatever happened to him as he recorded it in that uncanny book, his *Red Book*, toward the end of that journey Carl Jung tells us that he came upon Philemon, whom he calls The Magician, and upon Baucis, the companion of Philemon. Carl Jung has cribbed this story from Ovid, a fact that he wasn't trying to hide. In the tale as told by Ovid, Philemon and Baucis are an old couple who offer hospitality to two weary travelers who've been denied hospitality by everyone else in the town. But the travelers, as is often the case in such stories, aren't your average travelers. They are, in fact, Zeus and Hermes disguising themselves as humans. Philemon and Baucis open their house and their kitchen to the disguised guests and Baucis even goes so far as to offer up their only goose. She will go out and kill it and feed it to the travelers. But the goose runs to a safe place in the lap of Zeus and then the gods are revealed as gods, as always happens in these kinds of stories. A theophany.

Carl Jung and the serpent

Philemon and Baucis are told to find refuge in a high place outside of town and from there they watch terrible floods unleashed by the gods that destroy the town and everyone in it. Only a temple is left, a temple in the place where the house of Philemon and Baucis once stood. The old couple tend to the temple and, upon death, are turned into trees that look over the temple in perpetuity. End of story.

So Carl Jung, in his visionary fantasies, himself comes upon Philemon and Baucis in his search for a way to transform himself, his self, to find something within himself that he doesn't even know how to look for. He is searching for the true self, the other self, the second self, the Little Self. And Carl Jung finds old Philemon, who had been described to him by others as a magician. He wants to know more about this magic. Carl Jung finds Philemon and asks him about his magic. Philemon is tricky and circumspect. He crushes the hopes and expectations of his novice with the pitilessness of Old Silenus, the caretaker of Dionysius who crushes the hopes and dreams of King Midas. But Carl Jung, or the spirit or soul of Carl Jung, still wants to learn more about what magic really is, even though Philemon is trying to downplay the whole thing. Philemon says magic is something that can't be learned since it is the opposite of knowing and of understanding. Then what is it? Spirit Carl Jung wants to know. It is nothing, Philemon tells him. But what's the point of nothing? There is no point. Then there is nothing to do, Spirit Carl Jung concludes. Now you are starting to get it, Philemon responds.

The Grand Valley

After his meeting with Philemon the magician, Spirit Carl Jung concludes that magic is everything else, everything that lies outside the realm of what is otherwise accessed through knowing and understanding. That does not make it arbitrary, Spirit Carl Jung is quick to point out. The arbitrary would be understandable and therefore dismissible as being arbitrary. Magic is less understandable even than that. It emerges from what is effectively chaos, and chaos is neither reason nor unreason. It is something wholly other. It isn't arbitrary, and it isn't knowable either.

What then are you, Philemon? Spirit Carl Jung wonders. Who is the person who guards and attends to that which can't be known but must be accessed in some other way? And then Spirit Carl Jung answers his own question. You, Philemon, are the lover, Spirit Carl Jung realizes. The force of love itself who holds things together, who holds the empirical self together with the Other Self, the self that is and has always been completely beyond any specific determination. You, Philemon, are the particular and the absolute, bound in a way that makes no sense since there is no logic to it, and the absolute and particular are contradictories by any normal logic. But they are not contradictory by the nonlogic, the unlogic of The Magician, The Lover. The Lover, by that very force of cosmic union, can bridge everything that seems unbridgeable. That's something the old hermits and mystics used to say and that sometimes the medievals used to say. They used to say *amor ipse notitia est*. Love itself is a form of knowledge.

Carl Jung and the serpent

In a sense, Spirit Carl Jung realizes, Philemon, The Magician, The Lover, Philemon is also a kind of serpent. A serpent that coils around itself. A self that coils round itself. An ouroboros. A viper with the power to deliver wisdom as a kind of dissolving poison. And it is that very dissolving poison that also has within itself some capacity to heal.

28. Lord Chandos and the serpent.

AT THE END of Hugo von Hofmannsthal's famous *Letter*, Lord Chandos speaks of puttering around his estate and of how he sometimes falls into a mysterious, wordless, infinite rapture. Nothing grand produces this rapture. He speaks of the rapture as coming from something as small and mundane as "the stridulation of the last dying cricket as autumn winds are already driving wintry clouds over the empty fields." And this from a person who is writing about the absolute futility of expressing anything.

These inexpressible, though beautifully expressed feelings remind Lord Chandos of the ancient Roman orator Crassus. There is a specific story about Crassus. He had fallen in love with an eel that he kept in an ornamental pond. The eel died, and Crassus cried. Later, he was made fun of in the Senate for his tears. Presumably someone else saw Crassus crying about the eel and went and told everyone about it. And then Crassus was teased about his eel-crying especially by a rival senator named Domitius. Crassus replied, with the cutting words of the Roman orators of the time, that, with the death of his eel, he, Crassus, did what Domitius had failed to do

Lord Chandos and the serpent

when his first wife died. And his second. It is the addition of the second wife that somehow devastates. How can we fail to side with Crassus as he weeps over the lost eel while the snide Domitius can't even shed one tear over two dead wives?

Lord Chandos becomes rather obsessed with the idea of Crassus, dealing with the supposedly crucial affairs of the Roman Senate but actually weeping pathetically over the loss of his eel, this "dull, mute, red-eyed fish." This "ludicrous," this "contemptible" Crassus weeping over his eel keeps Lord Chandos up at night. The thoughts about Crassus become feverish and lead into a whirlpool. Lord Chandos / Hofmannsthal loses himself in this whirlpool, loses his self. The whirlpool is a place where language dissolves completely. And then it leads further down, into a place deep within Lord Chandos that is not really Lord Chandos anymore. And finally, the whirlpool leads down into a place of profound silence and peace.

Lord Chandos ends his letter by telling his interlocutor that he will write no more books. Lord Chandos, and by extension, we can also say Hugo von Hofmannsthal or some version of Hugo von Hofmannsthal, is interested now, like Crassus, only in a kind of mute language in which things, all the things of the universe, nonetheless speak. They speak without speaking. They speak a language that is understood only ever by the dead and those with whom the dead keep company. And it all happened because of a fish, an

The Grand Valley

eel, a serpent and the mute pathos at the center of the serpent's eye.

29. Paintings and words.

MANY OF THE big valley paintings that Joan Mitchell painted at the end of her life have secondary titles. They are all titled *La Grande Vallée*—*La Grande Vallée II* and *La Grande Vallée VII* and *La Grande Vallée XXII* and so forth. But some of them also have secondary titles or subtitles. *La Grande Vallée XIV*, with its flourish of bright yellow in the middle and a bit off to each side, this painting is also titled, in parenthesis (*For a Little While*). *La Grande Vallée XVI* also bears the title "pour Iva." Iva was the most beloved dog of Joan Mitchell, the mother of Marion and Madeleine, the dogs who were with her at the end of her life when she felled the serpent.

La Grande Vallée XX is also named Jean, for Joan Mitchell's gallerist Jean Fournier. And *La Grande Vallée XVIII* is also named Luc, for a monk named Frère Luc, a person whom Joan Mitchell revered and had some important conversations with in her last years.

This naming is the least Joan Mitchell could do for the people she loved and one of the last acts she performed as a painter. The paintings have nothing in particular to say about the ones who are named, the dogs and friends and interlocutors. The paintings aren't

The Grand Valley

about them, exactly. They reveal nothing and contain no signs, no clues. Just a naming. Each painting, a name. Each name, a painting. Each speaking of each name in the painting becomes an acknowledgment of a thisness. The paintings, in a sense, are themselves persons. And therefore can be anyone and everyone. Those people are now, and by virtue of Joan Mitchell's naming, themselves paintings. And they all dwell in the big valley. That is one thing Joan Mitchell accomplished from her sad hideout in a forgotten corner of France surrounded by the ghosts of Monet and Camille. She meditated on those people and dogs that had burned their importance into her life and she brought them all together, all to be held, all to be recognized in the vastness of the big valley, at the very center of which will always be a dark obscurity, an always-to-be-hidden core that is the same pulsing density she painted over and over again.

They are all, people, paintings, memories, they are all, in a sense, redeemed in their special and irreducible particularity. Each thing, each person, each painting exactly what it is. Absolutely. Beautifully. Strangely. Infinitely.

30. The final whirlpool into which Monet descended in his final paintings of the water lilies.

MONET WORKED ON many paintings, as well as many of the paintings that were to be his last will and testament, the big decorations, the massive canvases that were to find their final resting place in the special room at L'Orangerie Museum, just as World War I broke out, and while the great battles of the war raged not all that far away from his garden at Giverny. The Battle of Verdun, for instance, the longest of the horrible battles of World War I, was happening not so very far from where Monet was trying to figure out how to portray his water lilies along vast stretches of canvas, across an extent of painting-space larger and more horizontal than anything he had ever worked with before. Monet's own son, Michel, was a soldier in the war, though not specifically at the Battle of Verdun. Michel would survive the war and would inherit the gardens of Giverny, which he never cared much about, preferring fast automobiles and, in fact, dying in a car crash many years later in 1966.

As far as we know, as the art historians tell us, the seventh painting in Monet's last great water lilies series

at L'Orangerie Museum, the painting often referred to as *Waterlilies: Reflections of Trees*, was begun in 1915 and completed in 1926. So, Monet was painting this painting or at least thinking about this painting, working on it in his mind and wherever else one works on a painting, throughout the entire course of the Battle of Verdun and throughout most of World War I and then beyond. The painting is the darkest of the big decorations and the hardest one in which to get one's bearings, in my opinion. The light is quite dark. The painting swirls with blues and blacks and purple and dark green. And then some little bits of brighter color here and there where the flowers of the water lilies poke through. And that is how one finally gets one's bearings. Focusing on the flowers, one starts to realize where the surface of the pond is and where the reflections of the trees, which one cannot see directly, fall upon the water and create a surface that is also the reflection of something beyond, in this case the trees that only exist for us, the viewers of the painting, because the water exists.

Many things have been said about this painting and about the other paintings that make up the big decorations of the exhibit at L'Orangerie Museum. They have been talked about as paintings that lead to the kind of abstract painting practiced in New York City later, after World War II, which itself spiraled out from the events of World War I, the very events that happened outside Monet's window, as it were, while the water lilies were being conceived and painted. And the great wars of the early twentieth century are themselves linked to all the

The final whirlpool into which Monet descended

wars that came before, are they not? To the wars that have names and those that do not, to all the great and terrible comings-to-be and passings-away, to the forgotten and barely remembered dramas that can be given names like Troy and so forth, but that otherwise settle into a silence that drifts down over the centuries with the mute sadness of Silenus.

Doubtless it is true that certain possibilities of abstract painting, certain possibilities that would excite the abstract painters of a later generation as well as theorists like Clement Greenberg, were brought into the world by what Monet was doing with his water lilies. It is also possible that these paintings, and *Waterlilies: Reflections on Trees* in particular, do not especially lead anywhere at all. A possible thought to have, or, more importantly, a feeling to experience when looking at the painting *Waterlilies: Reflections on Trees*, is that the world is floating on itself. That's to say, there is nothing else upon which anything rests. There is nothing outside. There is nothing but what is, which is engaged in an act of dreaming itself into being through the intensive concentration of every bit of its whatness onto that very same whatness, and another way to say this is that the water and the flowers and the trees and the reflections of the trees and the various surfaces and the above-the-water and the below-the-water and the air and color and the light are all one thing, and that they relate to one another so perfectly because they never were anything but one another in the first place.

31. The final whirlpool of language that eats itself in the ouroboros of Gertrude Stein's *The Making of Americans*.

ANY PERSON WHO makes it to the end of Getrude Stein's completely unreadable book *The Making of Americans* is treated to passages like the following: "Any one can come to be one coming not to be going on being living. Any family living can be then being existing. Any one can come to be one coming not to be going on being living, in a family living, any family living can then have been something being existing. Any one can come to be one not going to be one going on being living. Any family can be one being existing. Any family living can be one having been existing."

People, as Gertrude Stein seems to want to tell us, are living in family and family is living in people and people come to be and the family comes to be and living itself comes to be and is being by nature of the being-existing of the family. That seems to be the gist of it. And knowing and needing also come to be because of this being of the family and the being of the ones in the family and through the family. And then, a few more

The final whirlpool of language that eats itself

passages on, old ones come to be dead. And this creates the possibility of remembering. A living, a moment where the old ones become dead, and remembering. And then, definitively, we reach the last few sentences of Gertrude Stein's impossible book: "Some being living and being in a family living and coming then to be old ones can come then to be dead ones. Any one can be certain that some can remember such a thing. Any family living can be one being existing and some can remember something of some such thing."

There is a very late painting by Joan Mitchell. I like to think of it as the very last painting that she painted, though I do not actually know if this is true and am not especially interested in finding out. It is an untitled painting, or you could say that it is a painting titled *Untitled*. It is a kind of diptych. It is made on two separate panels, as Joan Mitchell liked to do, and for me the painting is also a kind of final commentary on and concluding panel of the Big Valley paintings, even though it is not technically part of the Big Valley series and stands on its own. But I don't think it stands on its own. The painting has some of the same scritchy-scratchy energy as the Joan Mitchell paintings from the mid-1960s, and it has the same central intensities of colors and the same process of leaving a fair amount of white space and even has a hint of pink, the pink that sometimes pops out here and there in the Big Valley paintings and that sometimes makes me think of flowers, flowers perhaps that come from the kinds of plants that grow in ponds.

The Grand Valley

More than any canvas from any of the Big Valley paintings, *Untitled* is an explosion of yellow and orange. It has brightness and power and, I don't know, perhaps joy, as if for a moment the hidden delights of the big valley, the stuff back in the dense bushes of the foliage of the valley, we were treated to an explosion of color and brightness and light. Something emerges like a flash in this painting and then is already in the process of going away again, hiding, passing away and through and beyond. And yet still there, like Monet's sunflowers. Dead and alive. The very passing away of what is there in the process of being there. About to be gone. Gloriously.

Very soon after painting this painting, Joan Mitchell was to learn of the fast progression of her lung cancer. She was fragile from the jaw cancer that had come years before. She was moving about, when she could move about, with the walking cane, the very cane with which she had vanquished the serpent. She was working to put a few more swizzles of color on a few more canvases. And then, on October 30, 1992, she died.

In one of the very last scenes of *Joan Mitchell: Portrait of an Abstract Painter*, Joan Mitchell finally says a couple things about her paintings, about the forces that compelled her to paint. "Hopefully," she says, "something to do with a little love. Love of the river." She waves her hand and then pauses. "Love of the doggies." She takes a breath and swallows. "A mixture of looo," she is starting to say the word "love" again but doesn't finish, instead she replaces it with another word, "death and all that crap, you know." She rubs her lips.

The final whirlpool of language that eats itself

She stares into the camera for another moment. And then she is gone.

Further Reading

Stefany Anne Golberg. *My Morningless Mornings.* Okay, I happen to be married to this person. But I'm still going to claim that it is, objectively, an amazingly, really unbelievably beautiful book. Also, I "borrowed" many of my ideas about Jung and about the *Red Book* from this and other of Ms. Golberg's writings.

Carl Gustav Jung. *The Red Book.* An adorably nuts book. It reads like a throwback to the mystical visionary books of the Middle Ages. And that, I'm sure, was intentional.

Gertrude Stein. *The Making of Americans.* If you can read more than ten pages at a time you have near superhuman stamina. This book is tiresome and repetitive to the extreme. A work of genius.

Mary Gabriel. *Ninth Street Women: Lee Krasner, Elaine De Kooning, Grace Hartigan, Joan Mitchell, and Helen Frankenthaler: Five Painters and the Movement That Changed Modern Art.* These are five painters very much worth learning about. Some good stories about Joan Mitchell in here, too.

Further Reading

John Ashbery. "An Expressionist in Paris." It is annoying that someone who is a great poet does not stick to poetry but also manages to write brilliant art criticism. It is not fair. But there it is. Ashbery's collaboration with Mitchell, *The Poems*, is also very much worth checking out.

Dave Hickey. *25 Women: Essays on Their Art*. I know, the title is insufferable. And much of the time, so is Hickey. But the guy knew how to look at art. And he could write.

Ross King. *Mad Enchantment: Claude Monet and the Painting of the Water Lilies*. A fun read. And it did help me in understanding some things about Monet's last years and what he was up to with the water lilies.

Hugo von Hofmannsthal. *The Lord Chandos Letter*. Von Hofmannsthal is criminally underrated, in my opinion. Any collection that includes this text is worth reading in full. *The Lord Chandos Letter* is the most gut-wrenchingly powerful expression of literary Romanticism that exists. In my opinion.

Marion Cajori. *Joan Mitchell: Portrait of an Abstract Painter*. Pure Joan Mitchell. Straight, no chaser. Watch if you dare.

This book was set in Adobe OFL Sorts Mill Goudy,
designed by Barry Schwartz and published by The
League of Moveable Type, the first open-source font
foundry. Based on the classic Goudy Oldstyle, this
typeface retains the strong influence of calligraphy that
characterized its predecessor.

This book was designed by Shannon Carter,
Ian Creeger, and Gregory Wolfe. It was published
in hardcover, paperback, and electronic formats
by Slant Books, Seattle, Washington.

Cover art: Claude Monet, detail from *Reflets verts*,
Musée de l'Orangerie.

www.ingramcontent.com/pod-product-compliance
Lightning Source LLC
Chambersburg PA
CBHW020902180526
45163CB00007B/2598